Vintage VALUES

CLASSIC PAMPHLET COVER DESIGN FROM TWENTIETH-CENTURY IRELAND

Edited by Lir Mac Cárthaigh
Introduction by Niall McCormack

Published 2013 by Veritas Publications
7–8 Lower Abbey Street, Dublin 1, Ireland
publications@veritas.ie
www.veritas.ie

ISBN 978-1-84730-540-4
Copyright © Veritas, 2013

10 9 8 7 6 5 4 3 2 1

A catalogue record for this book is available from the British Library.

Designed by Lir Mac Cárthaigh
Printed in Ireland by Hudson Killeen

Veritas books are printed on paper made from the wood pulp of managed
forests. For every tree felled, at least one tree is planted, thereby renewing
natural resources.

Contents

Introduction

This selection of cover art from the Veritas archive of Catholic Truth Society (CTS) pamphlets is nothing short of a revelation. Bold, bright and vibrant, the designs eschew fussy ornamentation in favour of an uncluttered modern approach. They confound our preconceived ideas of an Irish Catholic visual culture during the Free State era.

The usual symbols of Catholic nationalism – Celtic interlace, shamrocks and harps – are almost completely absent. In fact, religious symbolism is avoided for the most part too. Instead the cover art employs the visual language of commercial art: a mix of the hard sell of advertising, the seductive allure of packaging and the immediacy of the comic book. There can be no doubt that the aim is to grab attention and stir curiosity.

The Catholic Truth Society of Ireland was founded in 1899. Its philosophy is best summed up by this wording which appeared in many of its pamphlets:

This booklet has a Mission – to make God known and loved. Maybe you can place it in the hands of somebody who needs it. Don't neglect to do so if you can. If you can't, leave it behind you on a park seat, in a 'bus, in a theatre, and Providence will guide it aright.

During the first half of the twentieth century, the 'scourge' of foreign influence – in the form of British and American books, films, magazines and newspapers – was seen as the main threat to the moral purity of the Irish people. Men and women in danger of succumbing to this tainted literature, immoral film or indecent dancing were the CTS's target audience, and the cover art was honed to appeal to their modern and urban tastes. The Church, it seems, had no problem embracing the visual language of this foreign culture.

Speaking at the Christus Rex Society's 1953 congress, Father Peter Birch, later Bishop of Ossory, outlined what was required of 'the Catholic pamphlet':

Pamphlets must be bright, cheerful and topical. We must use modern methods of production, display and salesmanship.

Their methods were certainly successful – Father Birch told the same congress that the CTS circulated 1,250,000 booklets in 1951. The details of print-runs in the CTS archive would suggest that this figure is not an exaggeration.

The Church's patronage of modern design is quite extraordinary considering that the then newly established Arts Council was having difficulties coming to terms with contemporary commercial art. In 1956 the Council deemed Guus Melai's modernist 'Four Courts' poster design for Aer Lingus to be 'of very little artistic merit'.

The charming two-colour creations which adorn the CTS pamphlets are certainly modern, if not modernist, and show Irish commercial artists were in tune with international trends in popular visual culture. Interestingly, the covers are closer in style to concurrent American designs than to European examples.

Between the wars, European commercial art embraced elements of high-modernism and numerous forms of popular modernism flourished. In America, the avant garde was less influential and commercial imperatives took precedence, with the vernacular 'showcard' approach remaining in style into the forties and fifties.

The showcard style is apparent throughout the CTS covers, particularly in the lettering and composition. Advertising display cards, or showcards, began as marketing tools in the Victorian era. By the start of the new century they had developed into a simple and direct hand-rendered form. By using expressive brush lettering and bold decorative alphabets, the commercial artist could achieve a fluid and attractive look which was difficult to obtain in letterpress.

The lettering on the pamphlets is very much of its time. *Murder by Accident* (1946) employs an art deco-influenced geometric style, while the later *What to do on a Date?* (1958) uses a mix of block lettering and brush script popular in the fifties. Both John Henry and Martin Collins show an assured grasp of the showcard aesthetic, mixing bold brush illustrations and confident lettering in strong compositions.

Much of the illustration is of a high quality too, although there is a strong preference for realism over stylisation or abstraction. The influence of cartoon and comic book art is strong, and it's no surprise that two of the artists, George Altendorf and George Monks, were accomplished cartoonists.

The fees for the pamphlet cover designs are quite a bit lower than those paid for full book cover designs by other Irish publishers during the period. George Altendorf received £1. 1s. 0d. for a cover design in 1935, unchanged since 1922 when George Monks received the same fee. One year earlier in 1934, The Talbot Press, not known for their largesse, paid twice the fee, £2. 2s. 0d., to Somhairle Uasal MacCana for the cover of *The Islandman*. In 1931 Austin Molloy received £3. 3s. 0d. from An Gúm for design of a generic dust jacket to be used on their Gaelic textbooks and general readers, although this was probably higher than their fee for a regular cover. To put this in context, Kelly's of Bachelor's Walk were advertising new Raleigh bicycles for £5. 7s. 6d. in 1935. The CTS fee rose to £1. 11s. 6d. in 1943 and eventually reached £3. 10s. 0d. in 1960.

The CTS archive contains a near full run of pamphlets from 1922 to 1972, almost five thousand individual titles, each one accompanied by an index card indicating the cover artist, fee paid, print-run and subsequent reprints. The archive is a unique repository of Irish commercial art from the formative years of the State. It represents an important strand of Irish visual culture which has until now been overlooked and uncelebrated. I hope that this lively and engaging selection will foster a new appreciation for these covers and the wealth of talented artists who created them.

Niall McCormack, 2013

Note: The date given refers to the year the artwork originally appeared. Many of these pamphlets were reprinted numerous times; sometimes different coloured inks were used on subsequent printings, often resulting in a very different image. When a later impression has been included, the year of printing is given between brackets. Covers that were entirely redesigned for reprint are designated as an 'edition'.

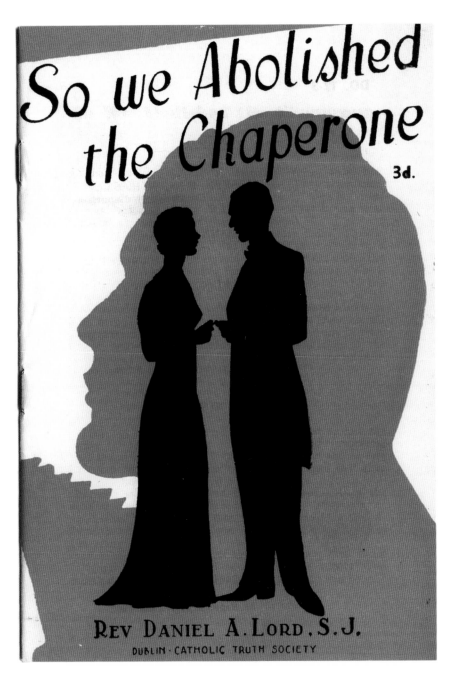

So We Abolished the Chaperone
1945 (*1963 printing*)
George Altendorf

**You've a Right
to be Happy!**
1943 (*1948 printing*)
Sean Best

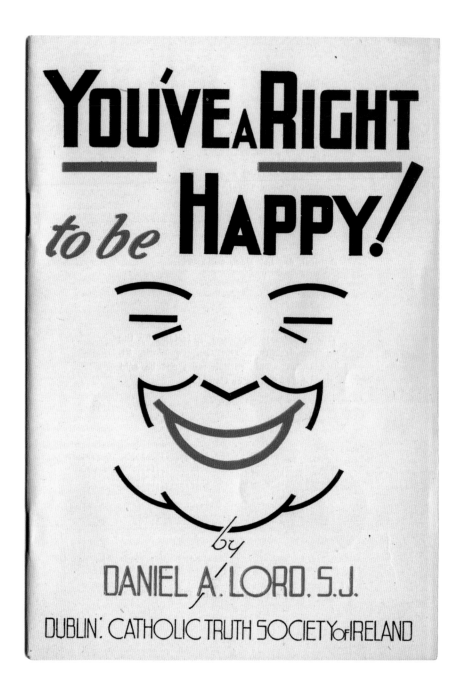

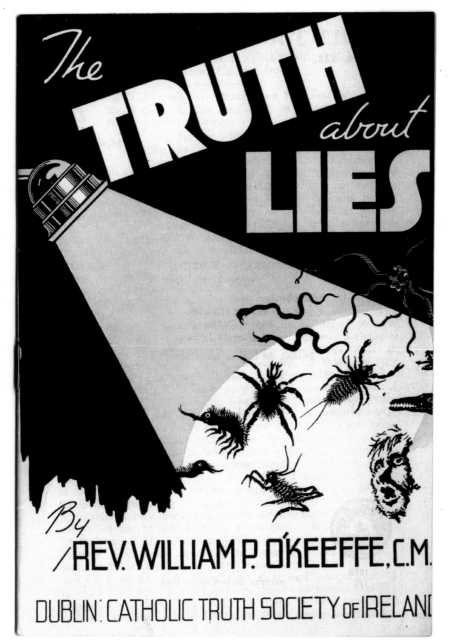

**The Truth
About Lies**
1945 (*1948 printing*)
Sean Best

Scruples: How to Avoid Them
c. 1944
(1960 printing)
Sean Best

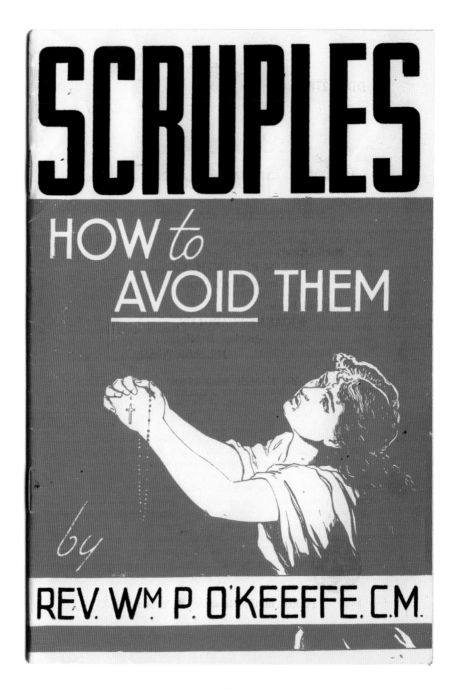

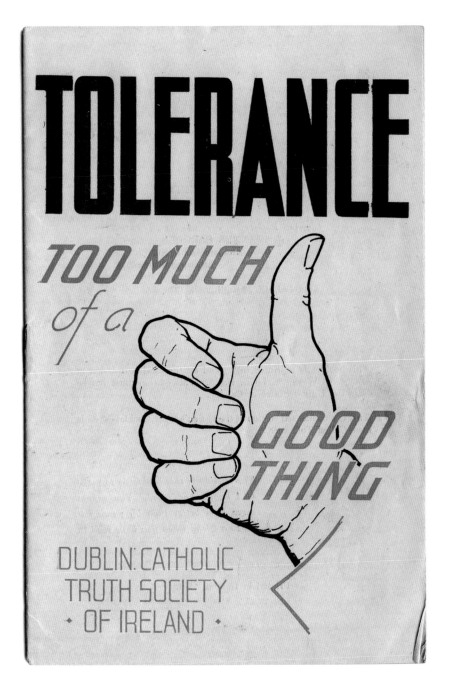

Tolerance: Too Much of a Good Thing
1944 *(1949 printing)*
Sean Best

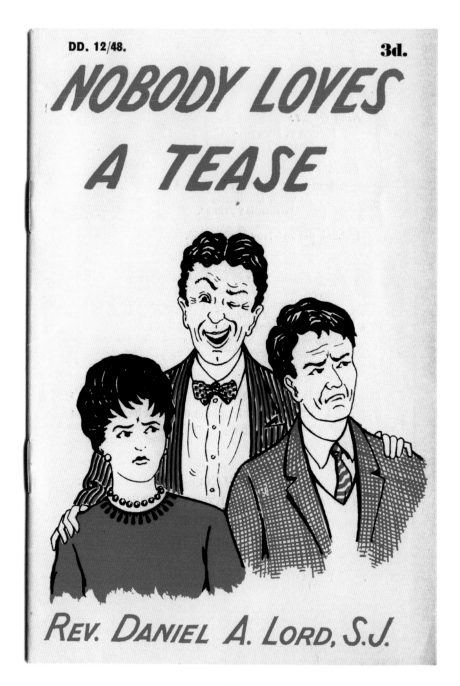

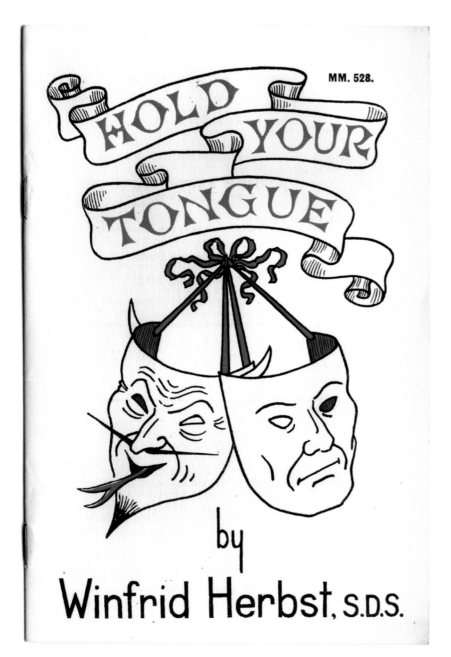

MM. 528.

HOLD YOUR TONGUE

by Winfrid Herbst, S.D.S.

Hold Your Tongue
1962 edition
(*1964 printing*)
W. Kiernan

**A Guide to
Fortune Telling**
1943 (*1953 printing*)
Sean Best

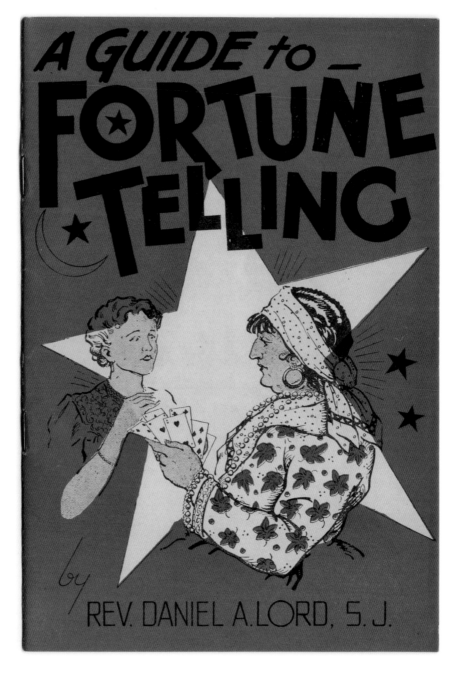

CARDS ON **THE TABLE**

By · Geoffrey · P · Dawley

DUBLIN · CATHOLIC · TRUTH · SOCIETY

Cards on the Table
1945 (*1952 printing*)
George Altendorf

I Was Going Steady
1961
W. Kiernan

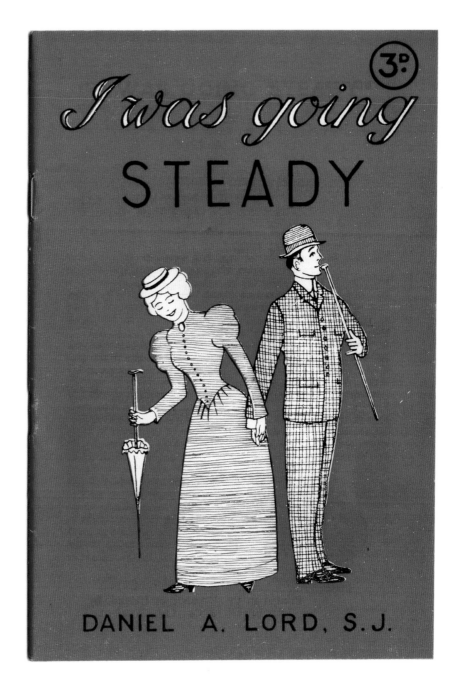

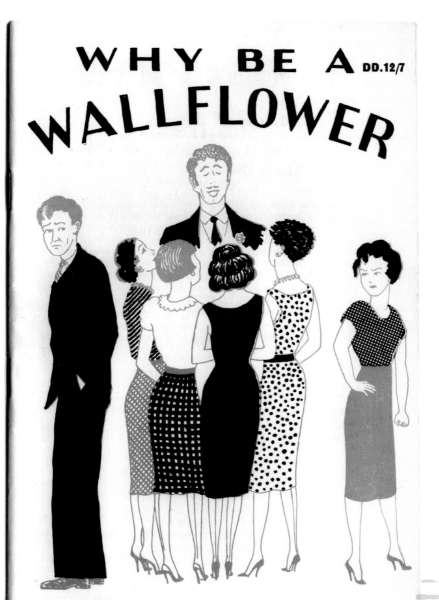

WHY BE A WALLFLOWER

DD.12/7

By DANIEL A. LORD. S.J.

Why be a Wallflower?
1958 edition
(*1964 printing*)
Martin Collins

What to do on a Date?
1958 edition
(1960 printing)
Martin Collins

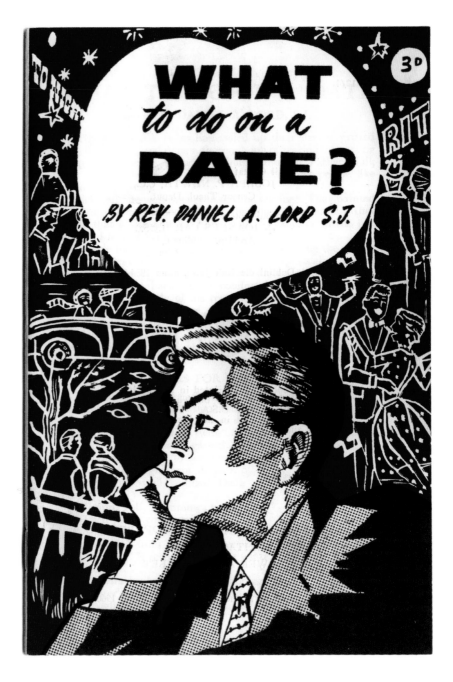

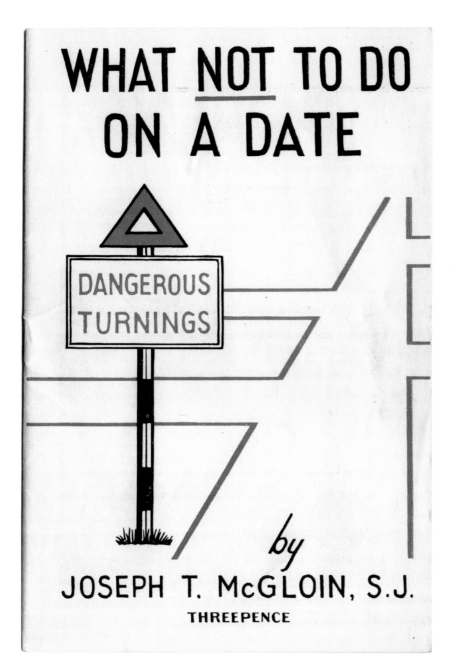

WHAT NOT TO DO ON A DATE

DANGEROUS TURNINGS

by

JOSEPH T. McGLOIN, S.J.

THREEPENCE

What Not to do on a Date
1960
W. Kiernan

7/2187051

His Choice
1931
George Altendorf

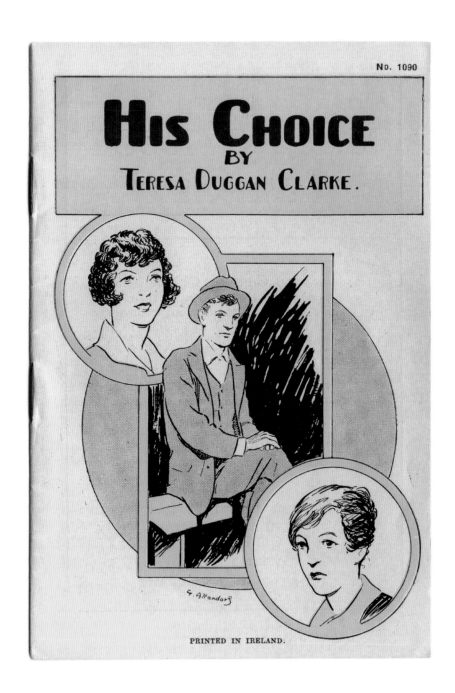

The Girl Who Wasn't Plain
1950
J. Spellman

**The Girl Worth
Choosing**
1955 *(1960 printing)*
John Henry

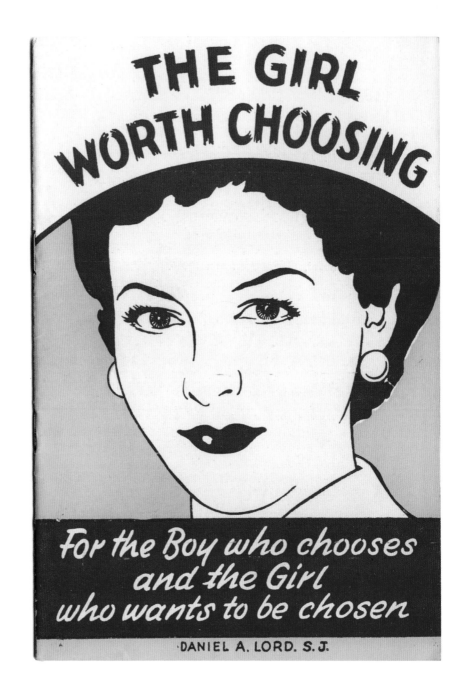

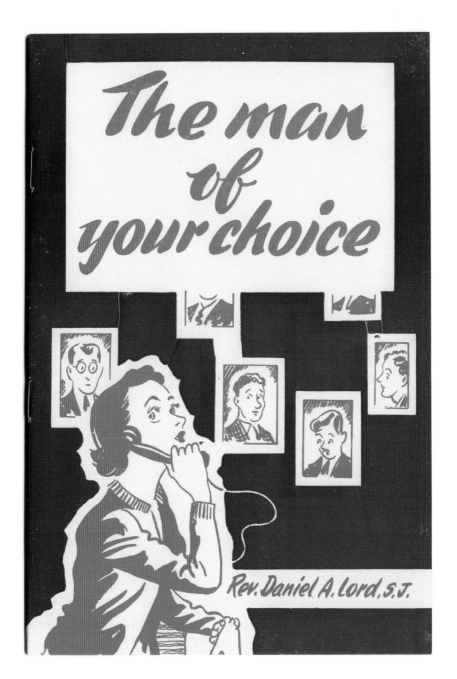

The Man of Your Choice
1955 (*1963 printing*)
John Henry

Miss Modern
1951
George Altendorf

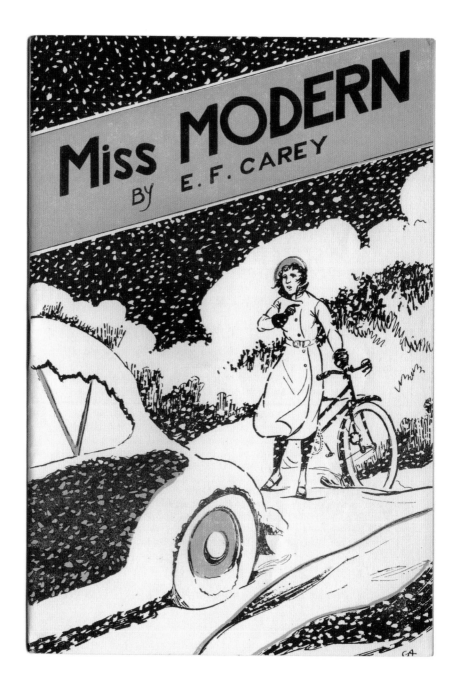

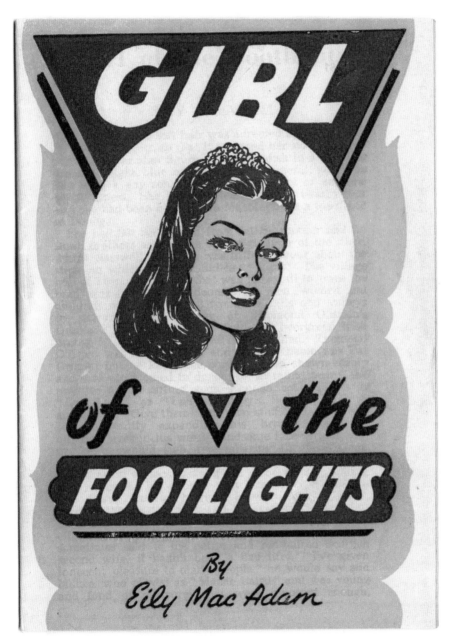

Girl of the Footlights
1949
George Altendorf

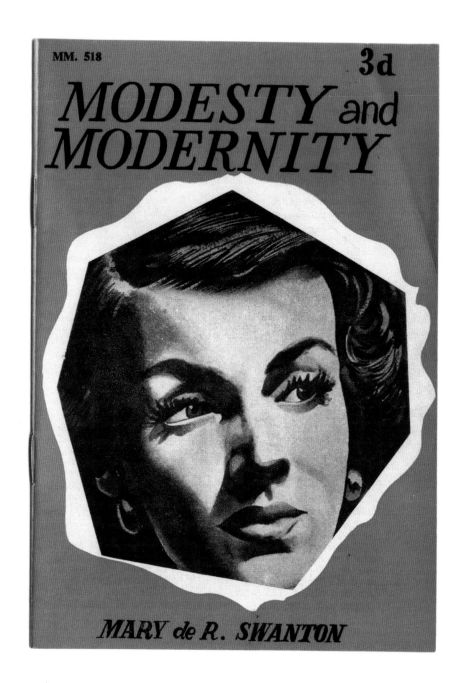

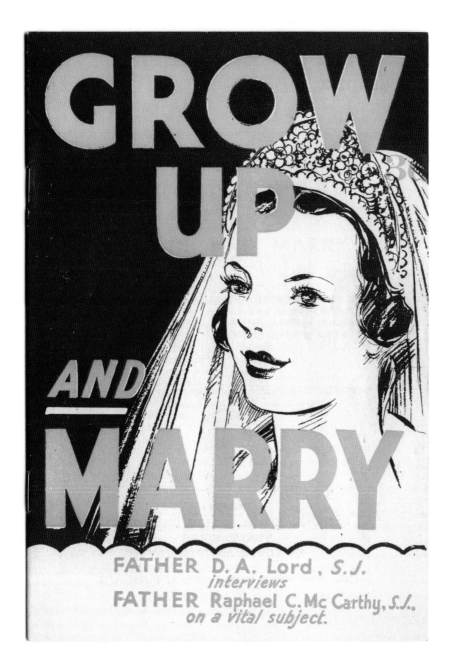

Grow Up and Marry
1947 (1958 printing)
Elgin Studios

Don't Marry a Catholic
1955 (*1957 printing*)
John Henry

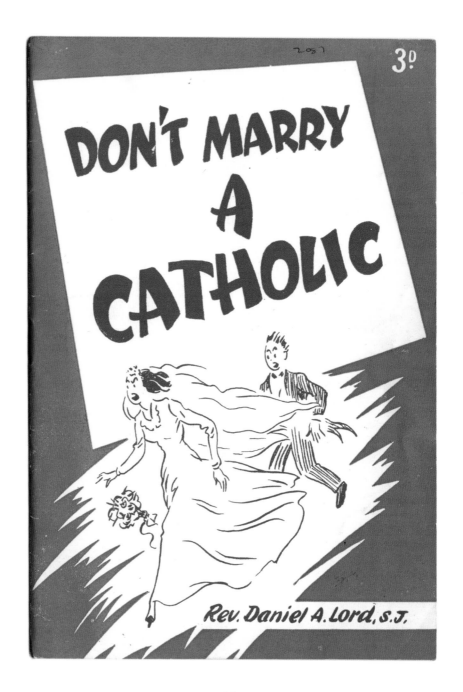

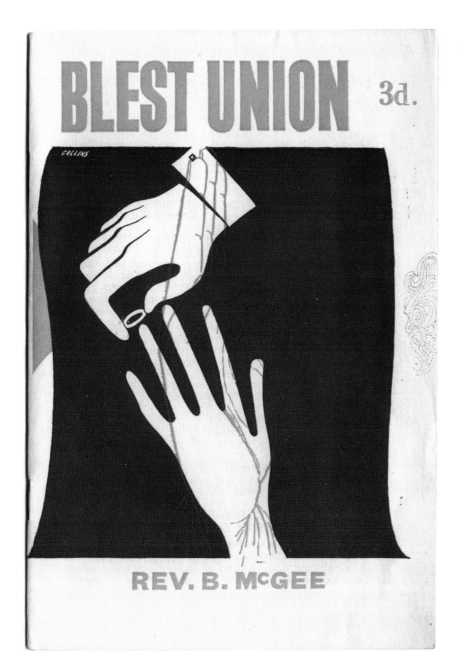

Blest Union
1958 edition
Martin Collins

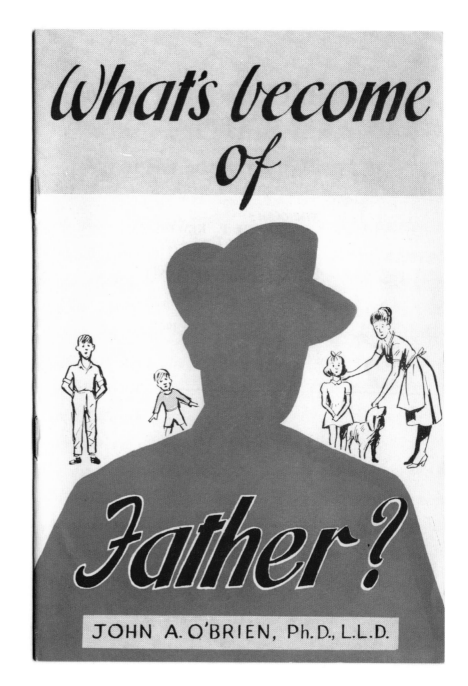

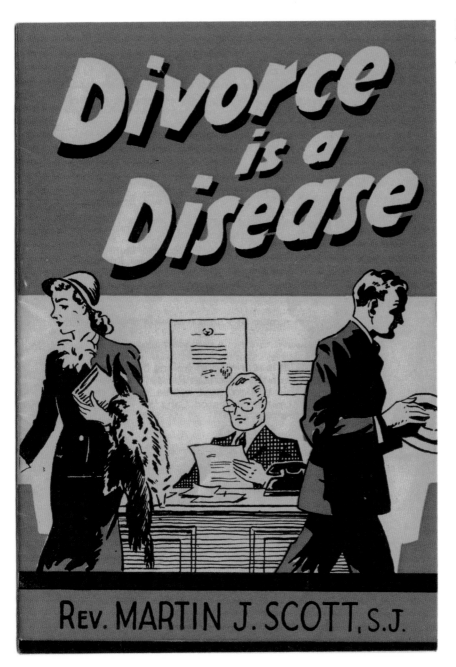

Divorce is a Disease
1944 (*1957 printing*)
John Henry

**Shall My Daughter
be a Nun?**
1945 (*1957 printing*)
John Henry

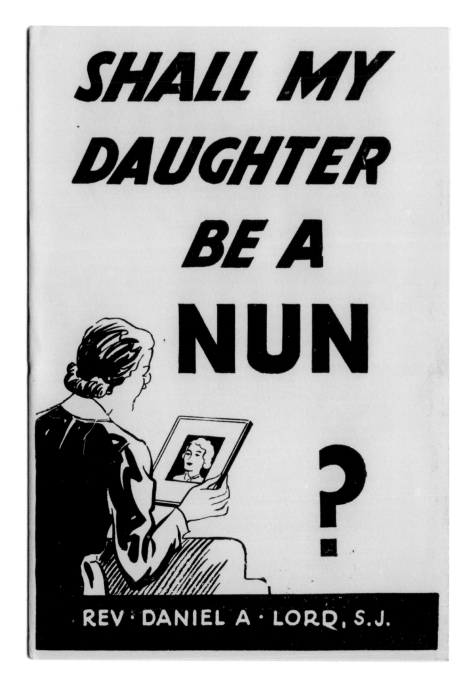

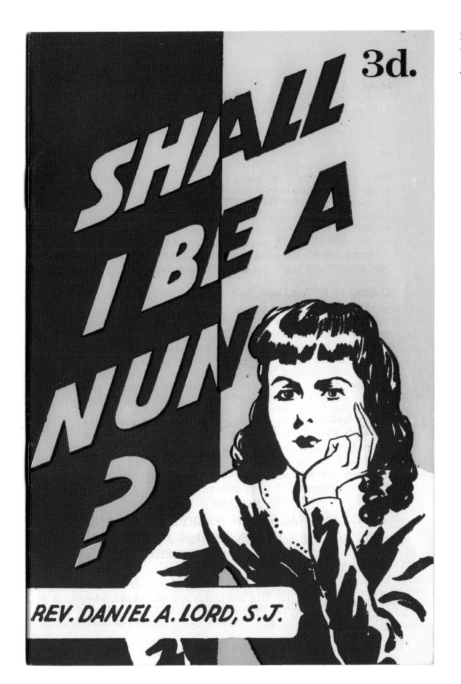

Shall I be a Nun?
1945 *(1960 printing)*
John Henry

Hell
1945 (*1957 printing*)
Sean Best

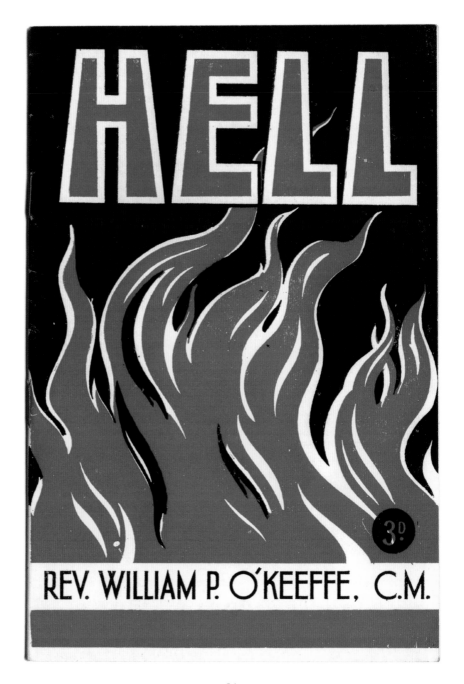

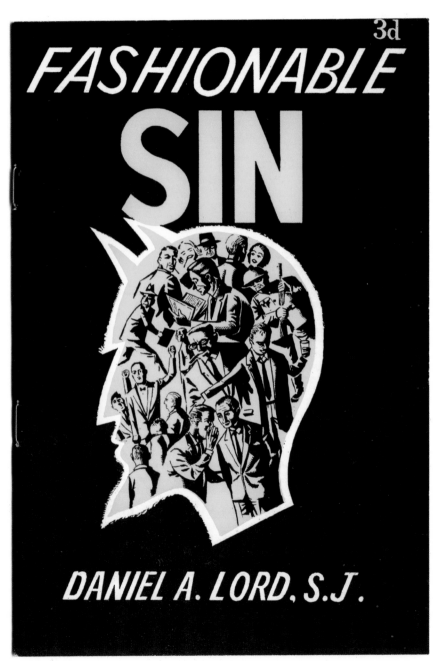

FASHIONABLE

SIN

3d

DANIEL A. LORD, S.J.

Fashionable Sin
1957 edition
(*1963 printing*)
Martin Collins

Angels and Devils
1950 (*1962 printing*)
J. Quinn

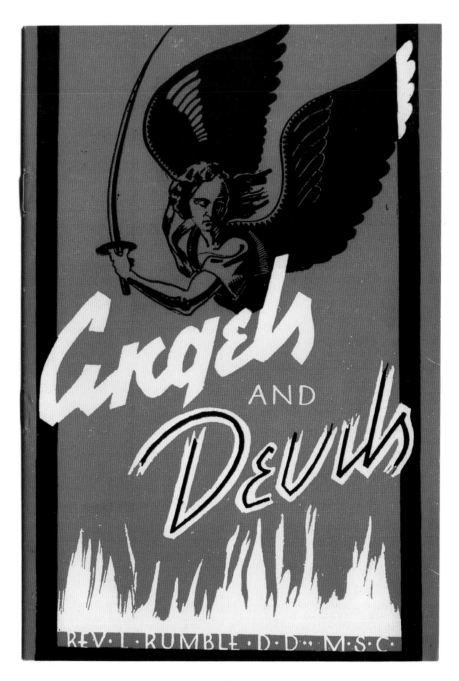

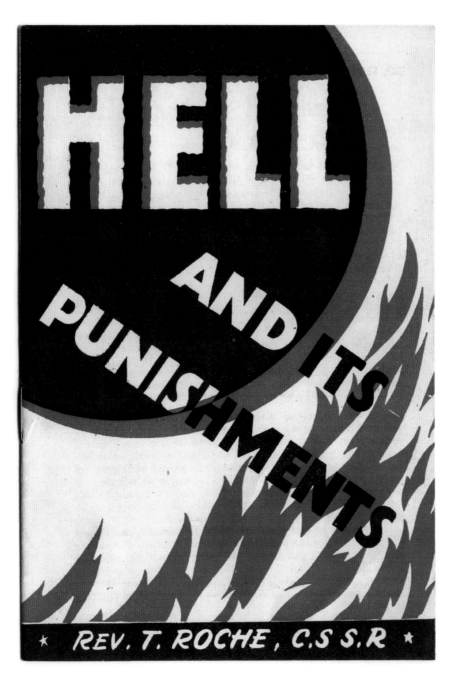

**Portrait of a Communist &
Does Communism Threaten Christianity?**
1957 edition
(*1960 printing*)
G. O'Byrne

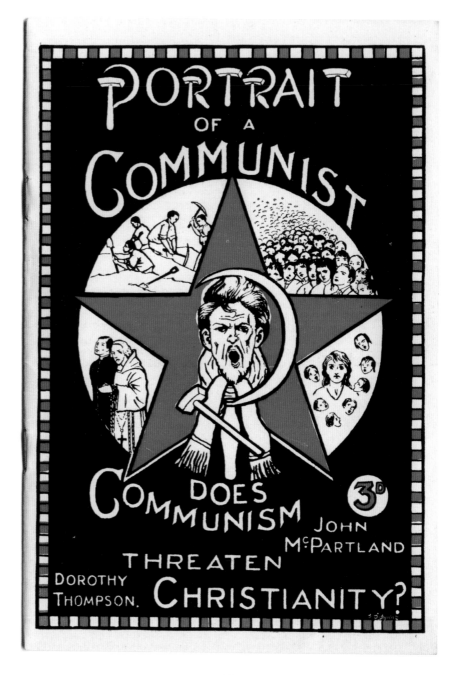

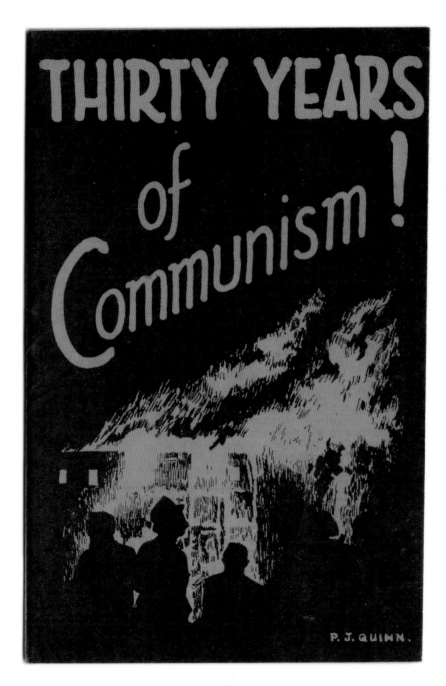

Thirty Years of Communism!
1951
P.J. Quinn

**God and Evil:
A Conversation
with Martin**
1948
John Henry

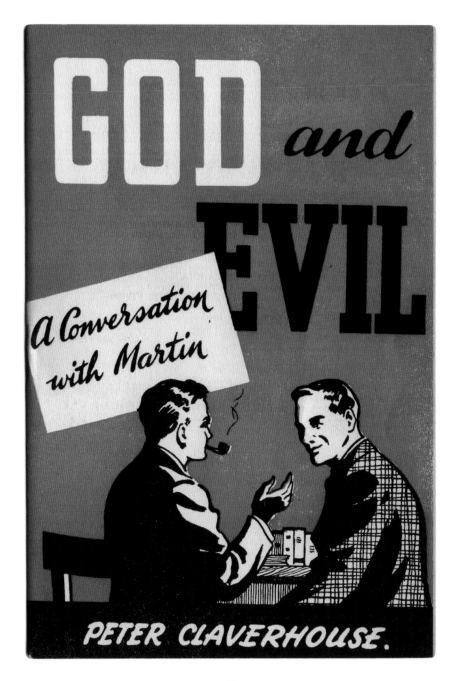

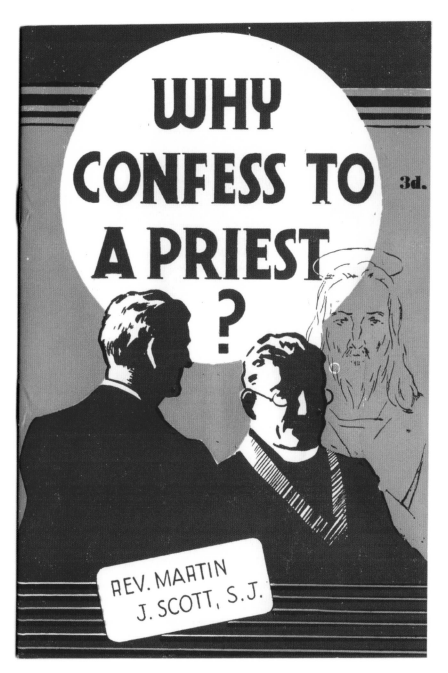

Why Confess to a Priest?
1945 (*1964 printing*)
John Henry

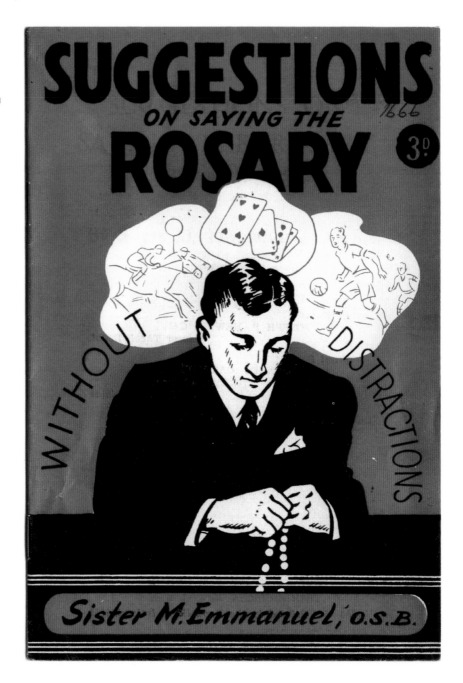

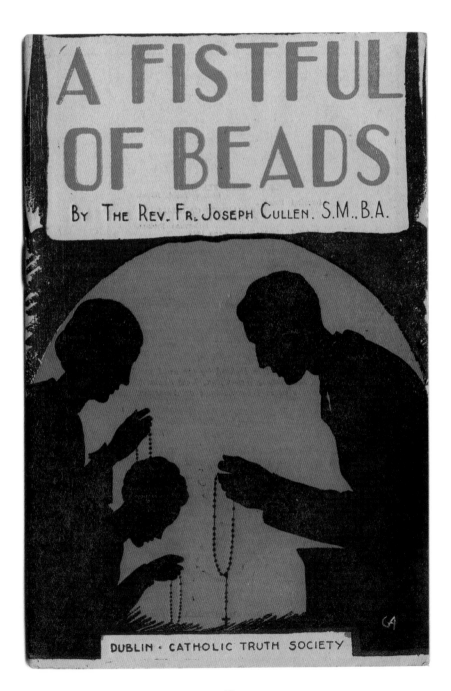

A Fistful of Beads
1946
George Altendorf

The Beefy Saint
1922 (1962 printing)
George Monks

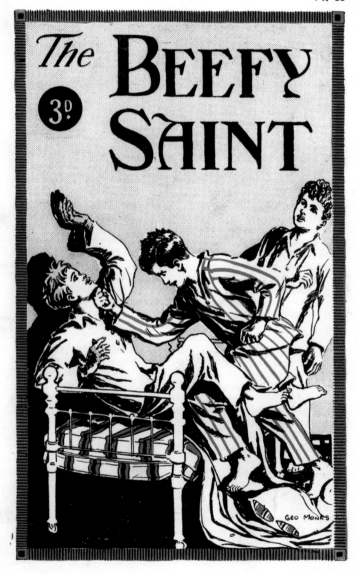

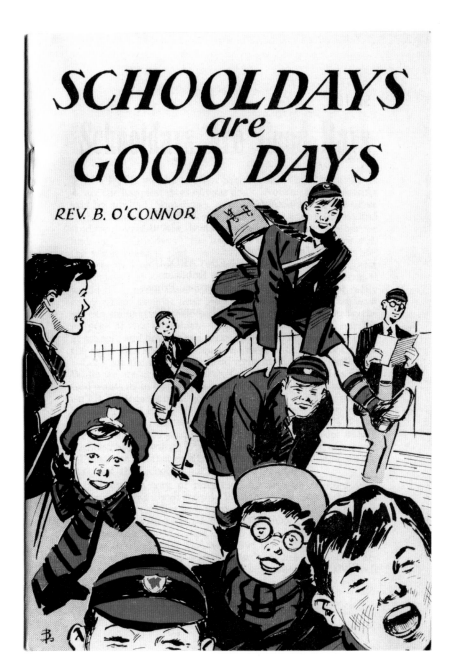

SCHOOLDAYS
are
GOOD DAYS

REV. B. O'CONNOR

**School Days Are
Good Days**
1963
M. Byrne

Mary Ellen
1944
George Altendorf

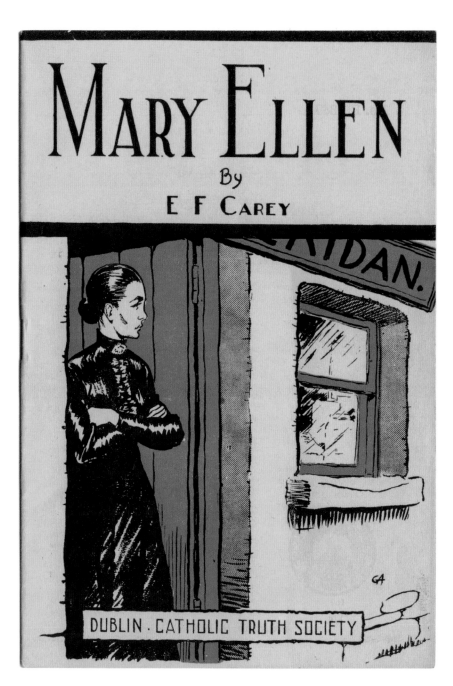

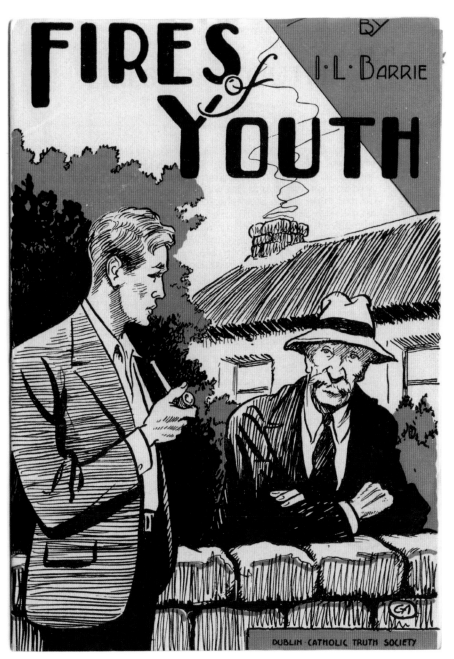

Fires of Youth
1948
George Altendorf

I Am Afraid
1949
Karl Uhlemann

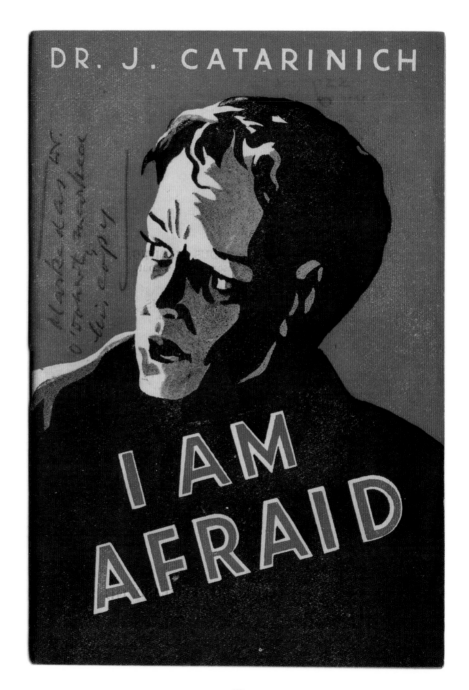

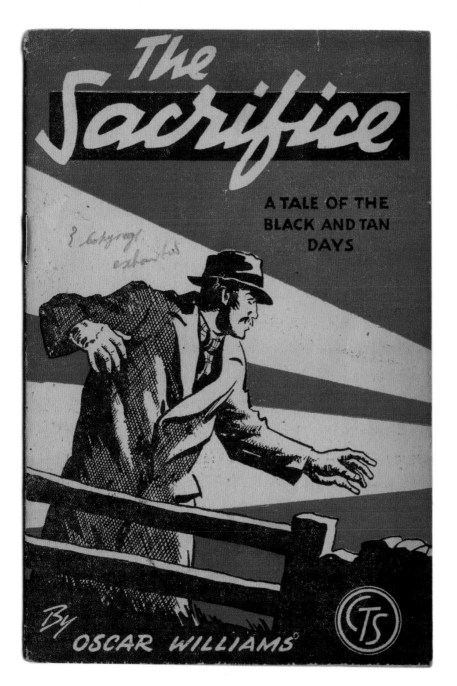

**Jonathan
Fiddlesticks**
1950
George Altendorf

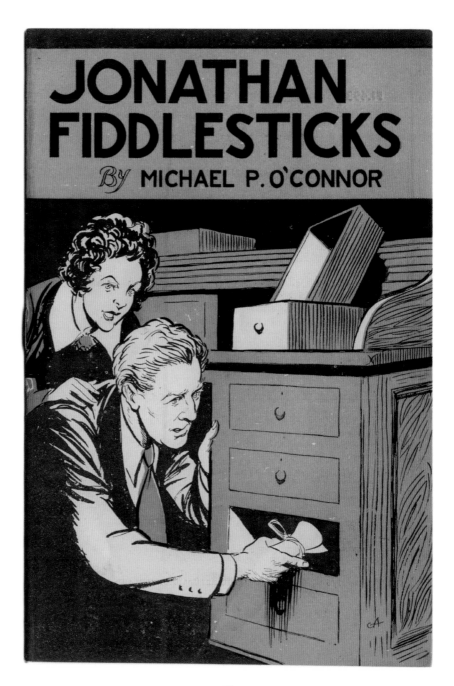

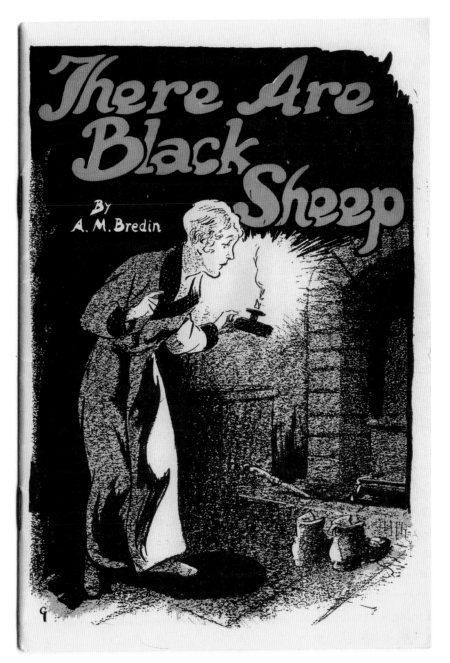

There Are Black Sheep
1934
George Altendorf

He Kept It White
1945 *(1947 printing)*
George Altendorf

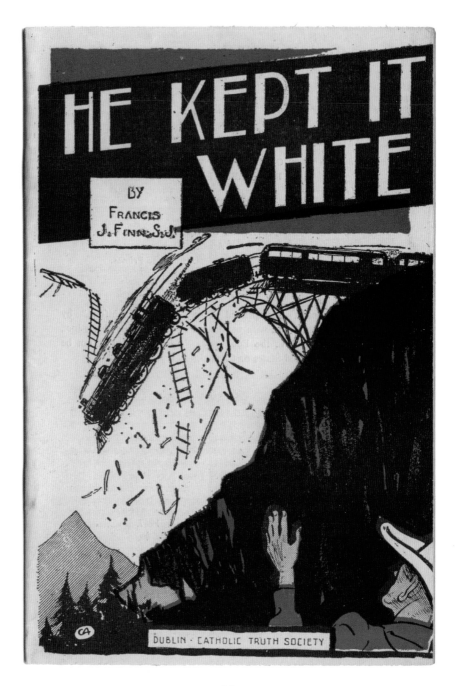

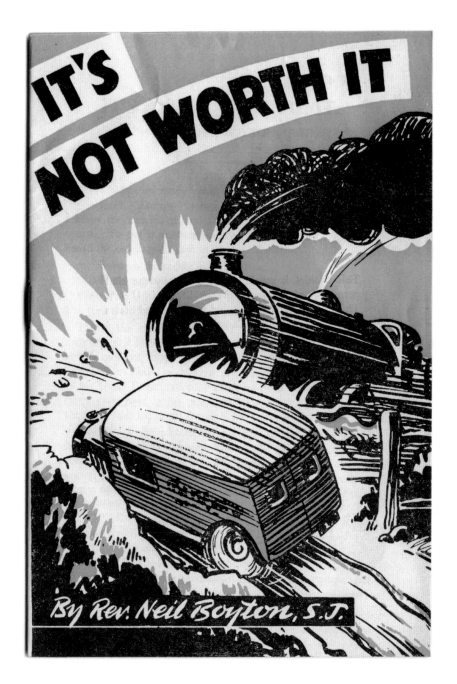

It's Not Worth It
1946 (*1950 printing*)
John Henry

**The Firefighters and
Other Stories**
1934
George Altendorf

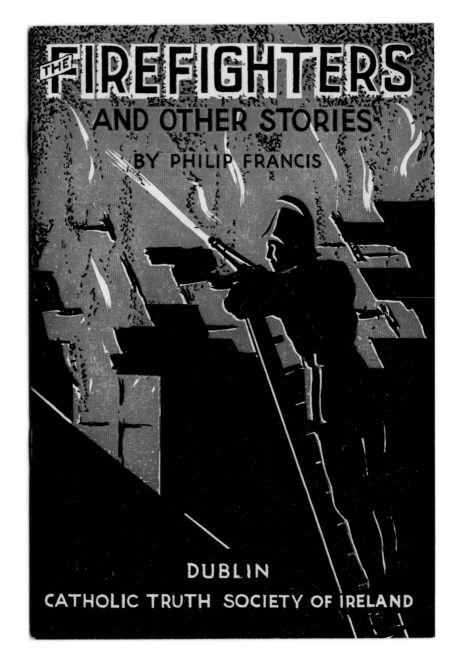

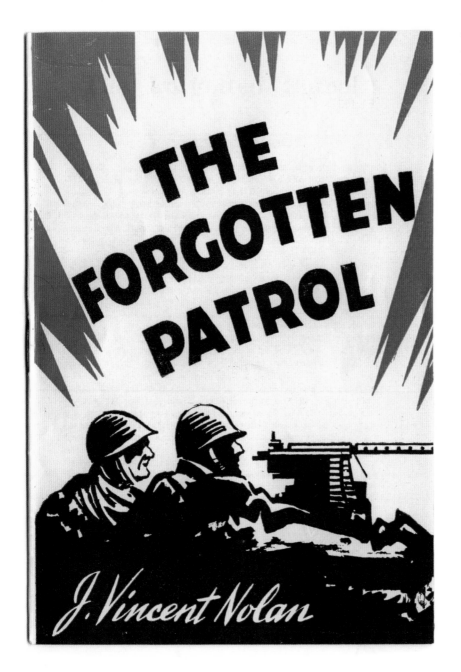

The Forgotten Patrol
1950
John Henry

Down at the Barber's
1951 edition
J. Verner

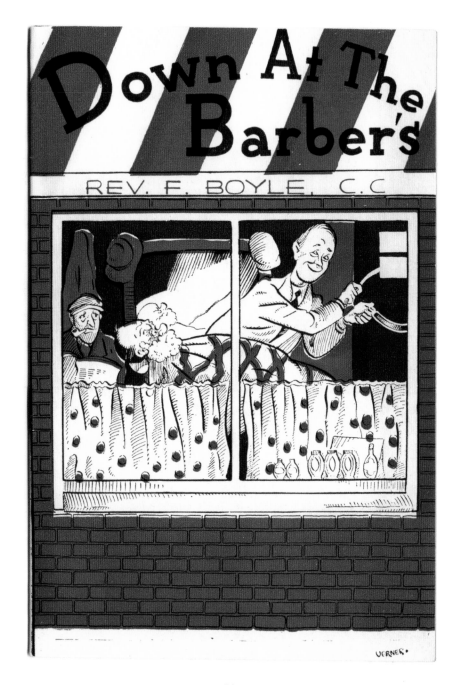

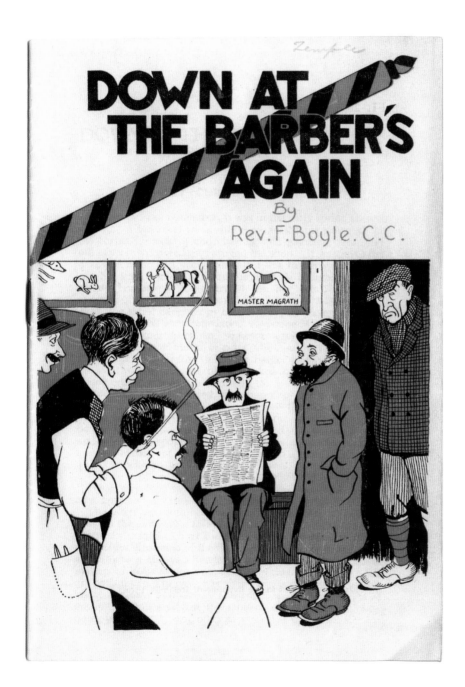

Down at the
Barber's Again
1935 (1950 printing)
Unknown

Dirty Stories
1944
George Altendorf

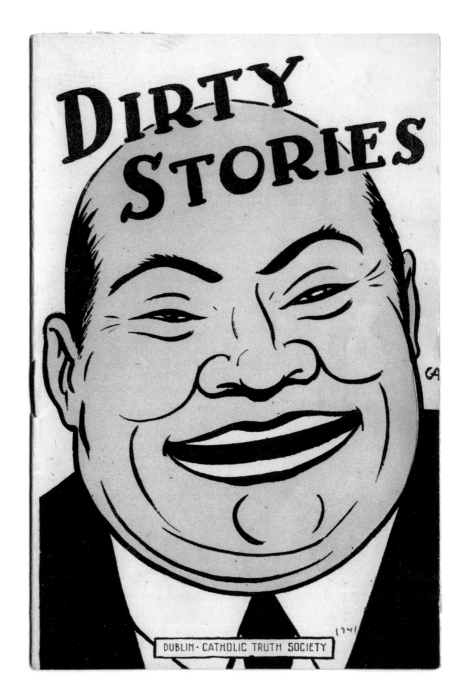

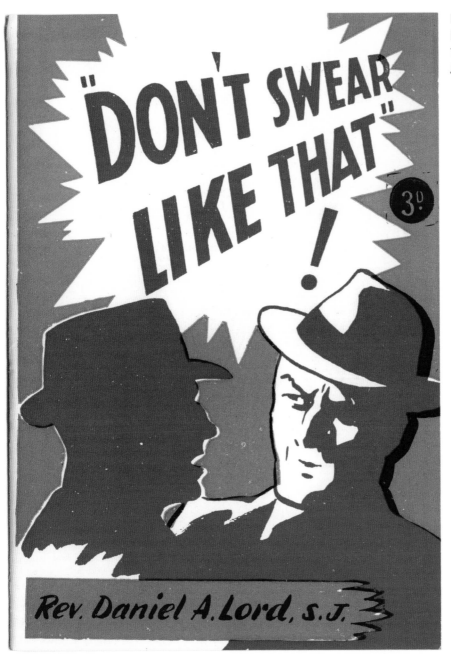

Don't Swear Like That!
1948 (*1957 printing*)
John Henry

Shall I Start to Drink? Decide for Yourself
1953 (*1959 printing*)
John Henry

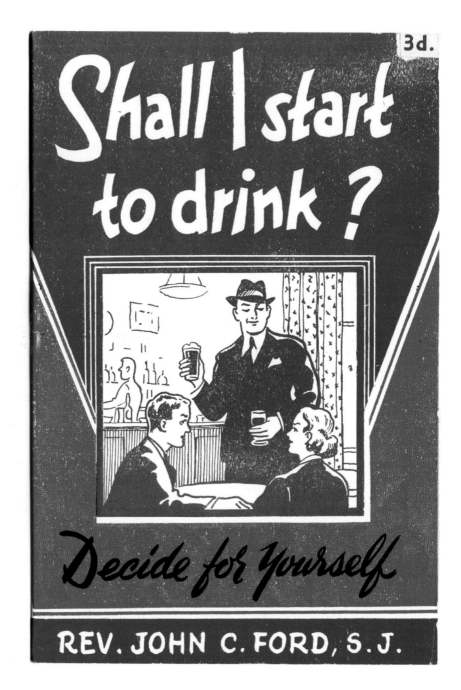

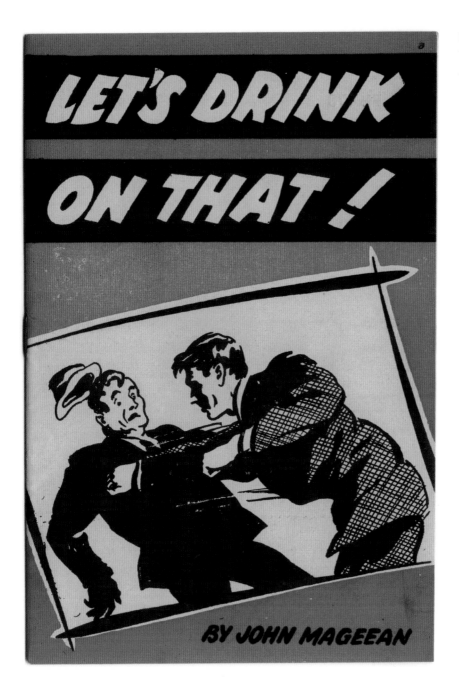

Let's Drink On That!
1948
John Henry

Symphony in One Bar
1948
George Altendorf

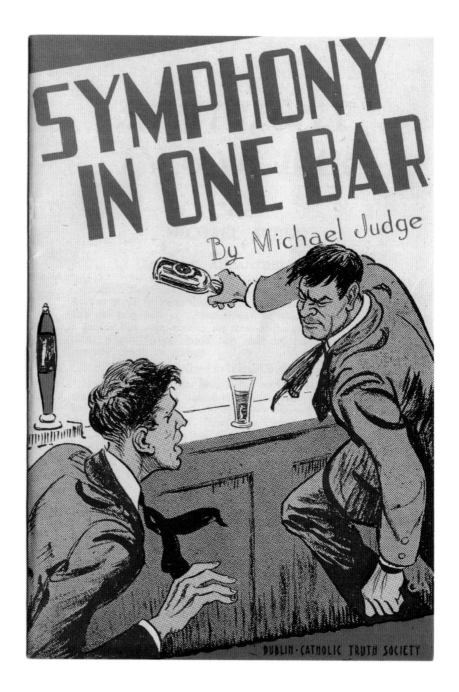

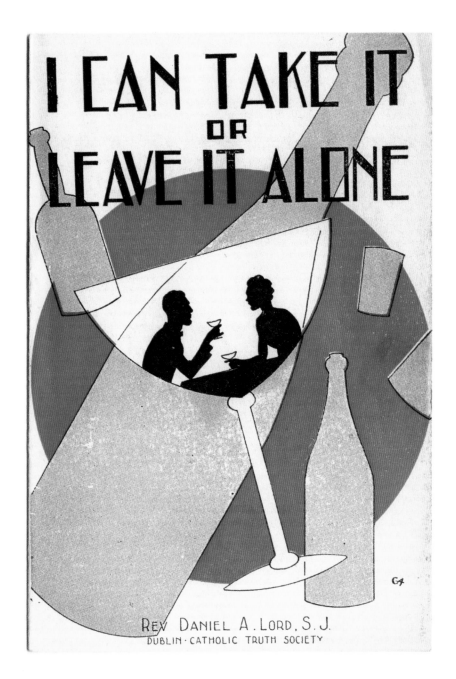

**I Can Take it or
Leave it Alone**
1945 (*1957 printing*)
George Altendorf

Out for the Count
1950
George Altendorf

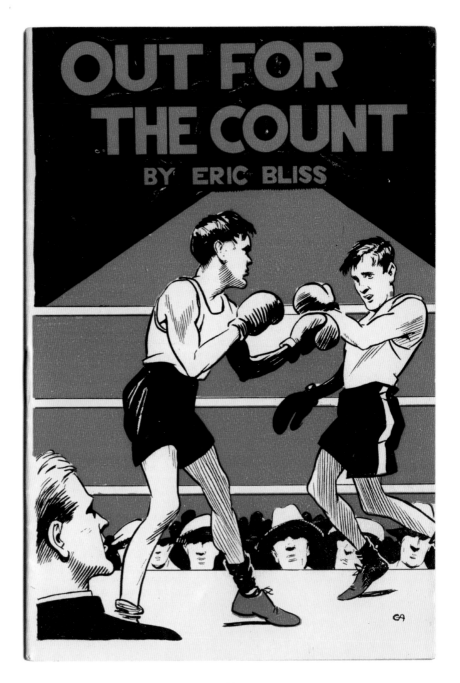

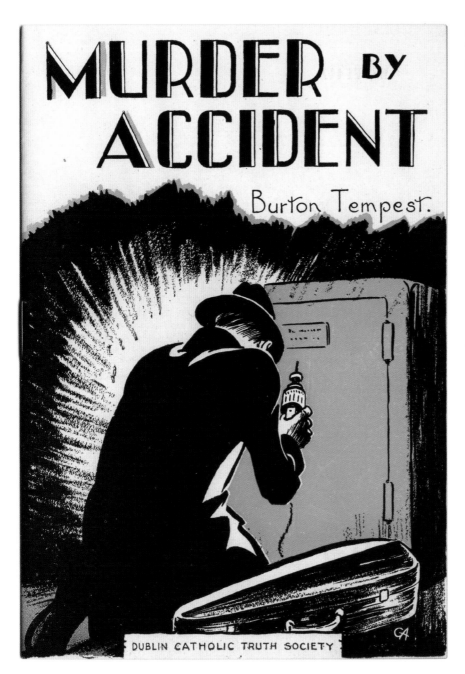

Murder by Accident
1946
George Altendorf

**The Pen-Man
Murder Mystery**
1946
George Altendorf

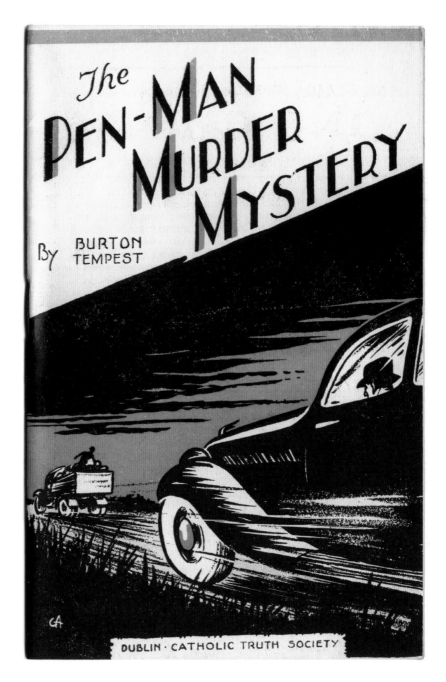

The Dead Do Not
Move
1951
P.J. Quinn

The Angels of Death
1951
J. Verner

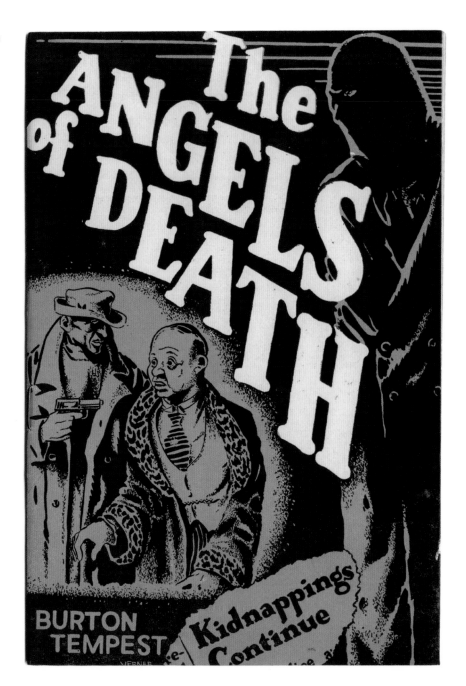

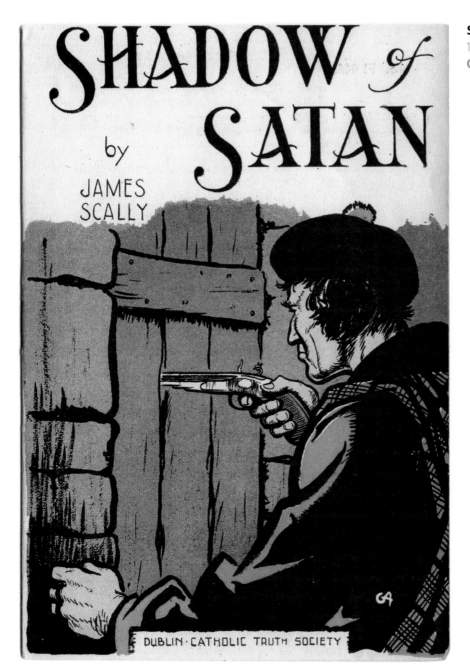

Shadow of Satan
1946
George Altendorf

Sister Felicitas Wins a Bicycle
1952
George Altendorf

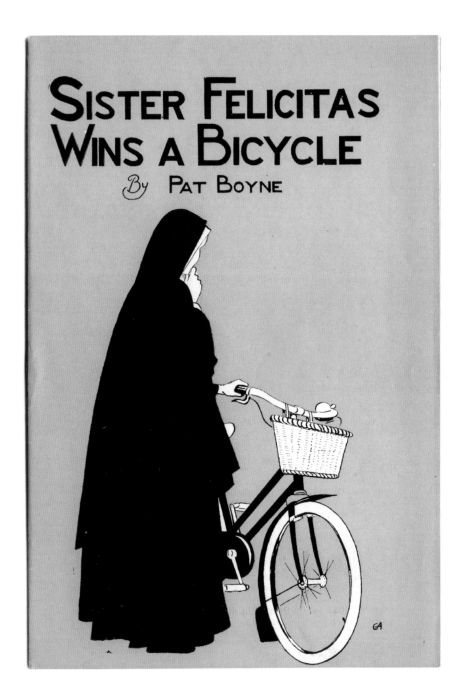

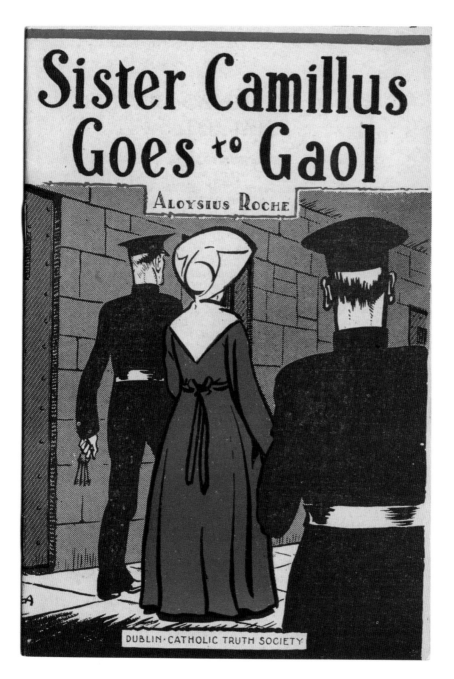

**Sister Camillus
Goes to Gaol**
1944 *(1947 printing)*
George Altendorf

**Granny's Path
to Rome**
1948
George Altendorf

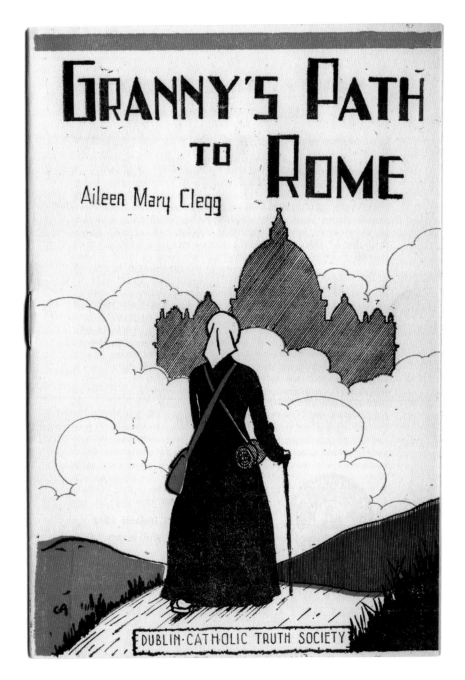

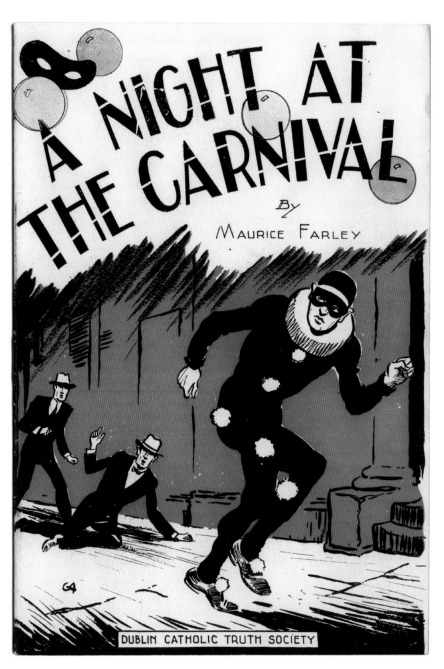

**A Night at the
Carnival**
1945
George Altendorf

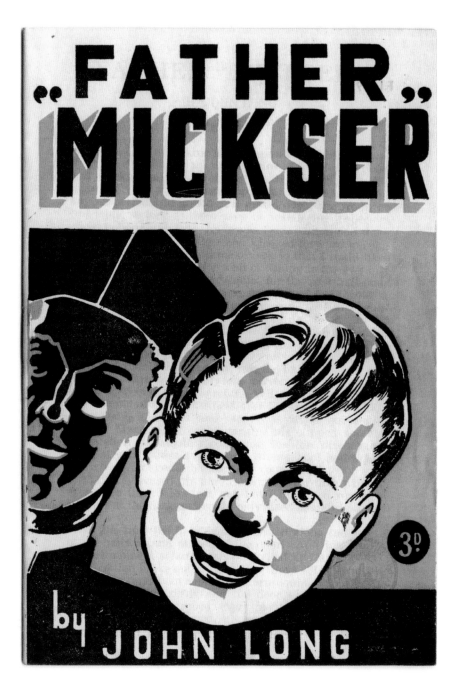

Jack and the Wishing Gnome
1946
George Altendorf

What Kevin Was Doing & The Girl Who Was Frightened of Cows
1953 (*1964 printing*)
George Altendorf

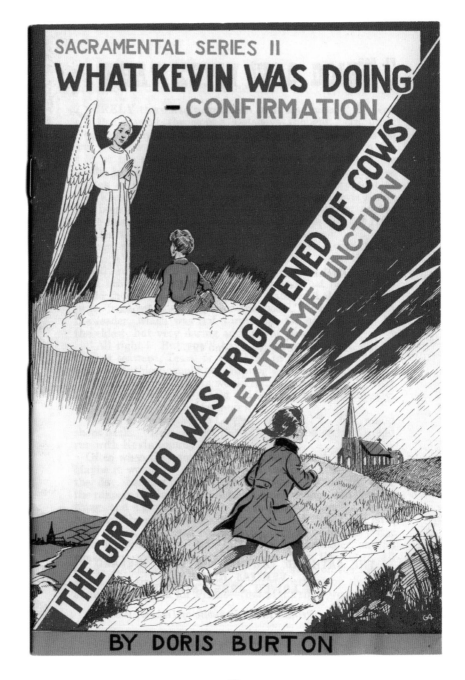

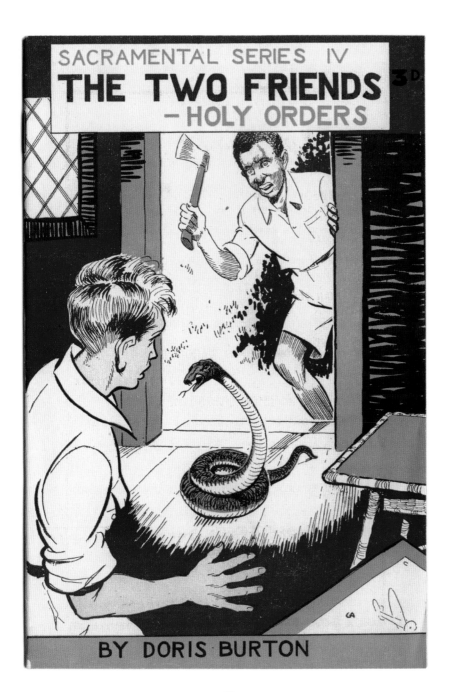

The Two Friends
1953 *(1958 printing)*
George Altendorf

**The Sword of
the Archangel**
1944 (1947 printing)
George Altendorf

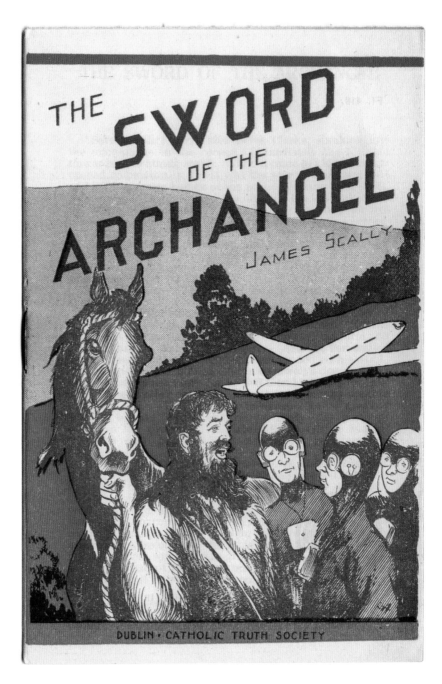

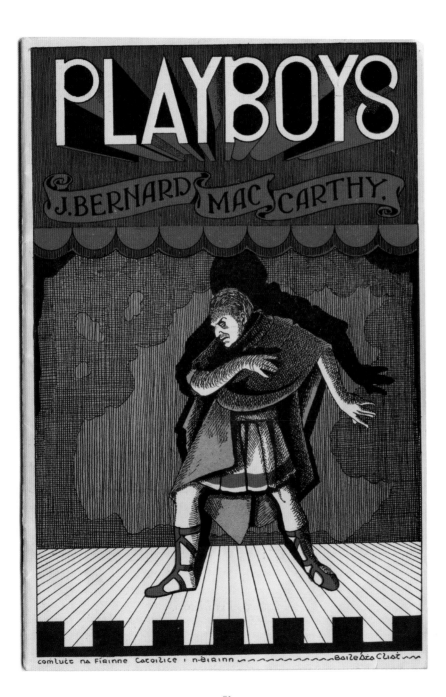

Playboys
1935
Alfred Monahan

Heavenly Hide and Seek
1946 *(1948 printing)*
George Altendorf

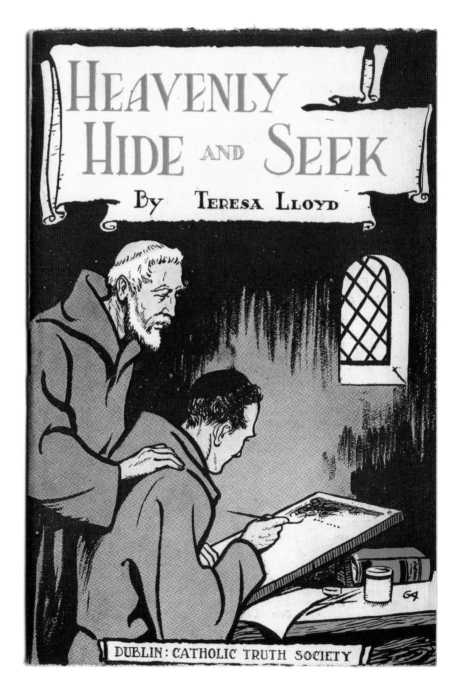

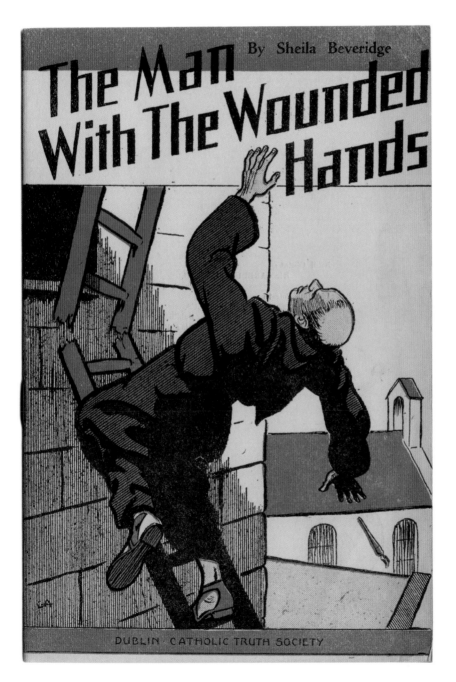

The Man with the Wounded Hands
1946 (1949 printing)
George Altendorf

The Path to Santo Domingo
1946 *(1949 printing)*
George Altendorf

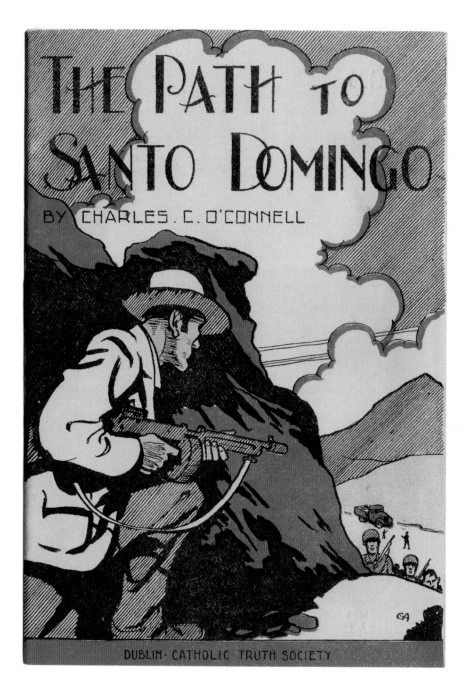

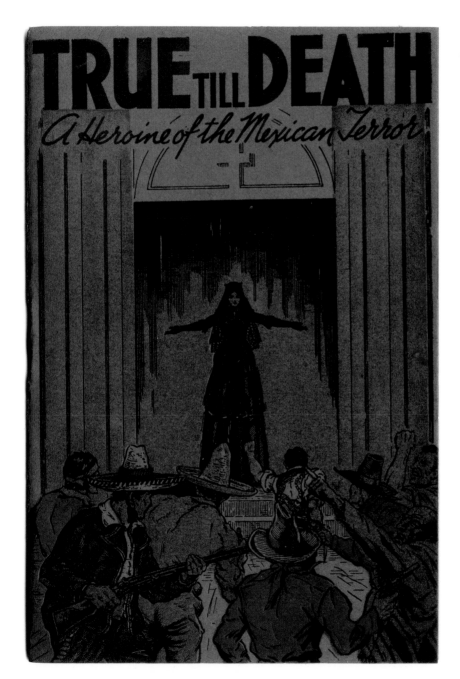

**True Till Death:
A Heroine of the
Mexican Terror**
1939 *(1944 printing)*
Sean Best

**Captain of the
Brigade**
1935
Alfred Monahan

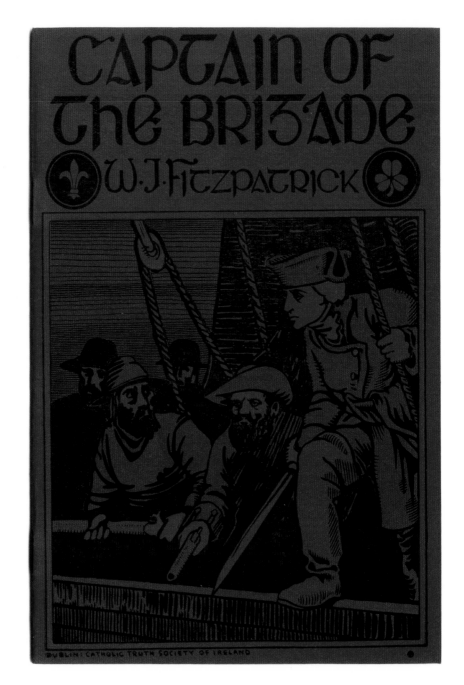

**A Young Rebel
Meets God**
Late 1930s
(1963 printing)
Alfred Monahan

**Ondesonk the Wolf:
A Tale of the Canadian
Martyrs**
1933
George Altendorf

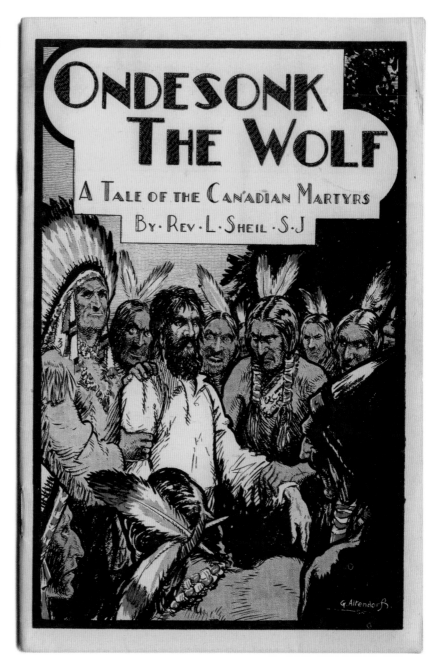

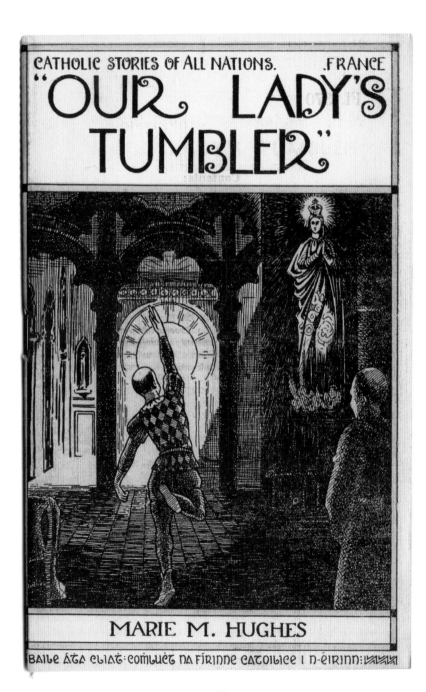

Our Lady's Tumbler
1940 (1948 printing)
Alfred Monahan

Pleasure in Giving
1944 (1945 printing)
George Altendorf

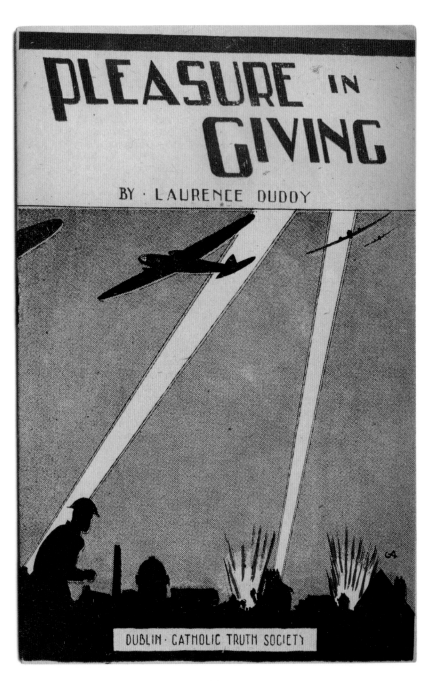

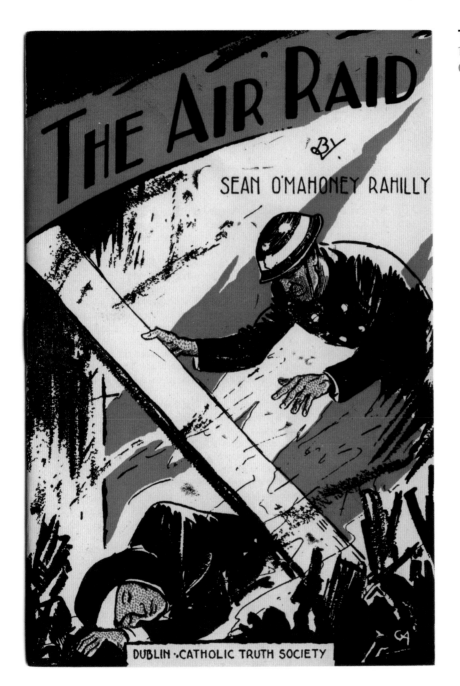

The Air Raid
1947 (1950 printing)
George Altendorf

Mad Dog
1944 *(1947 printing)*
John Henry

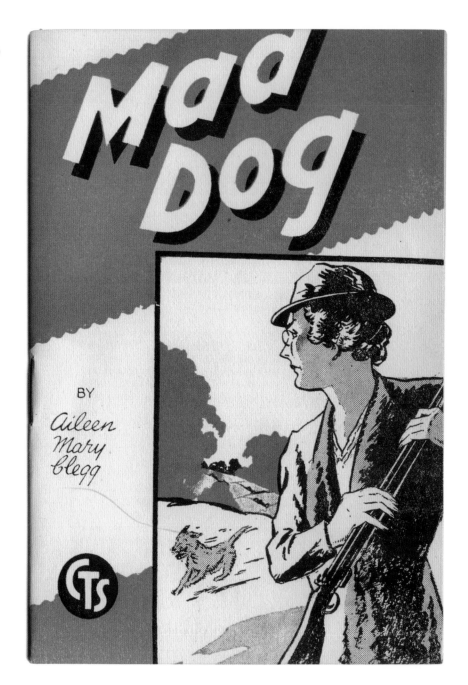

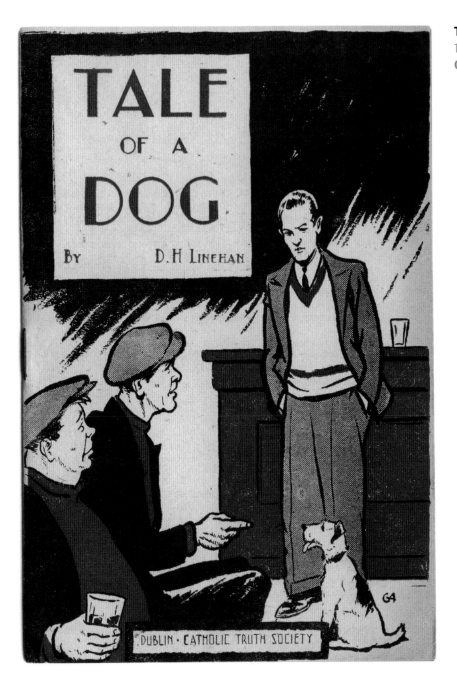

Tale of a Dog
1944 (1945 printing)
George Altendorf

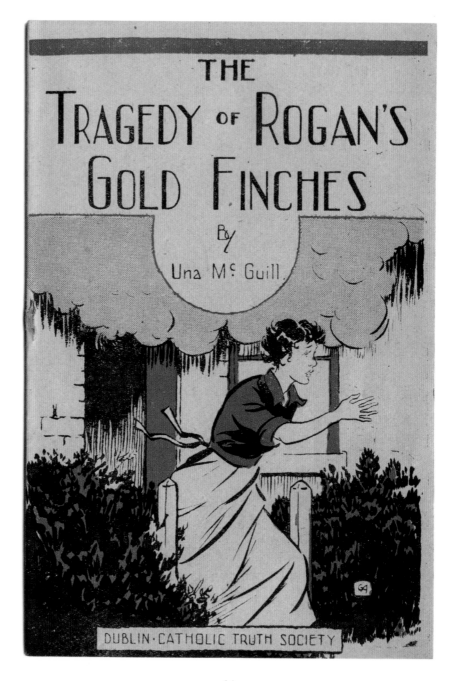

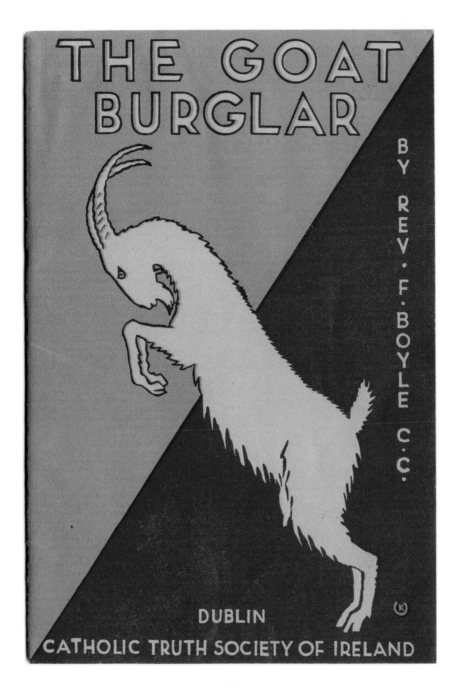

THE GOAT BURGLAR

BY REV · F·BOYLE C·C·

DUBLIN
CATHOLIC TRUTH SOCIETY OF IRELAND

The Goat Burglar
1935
Karl Uhlemann

Donovan's Last Case
1945 (1947 printing)
George Altendorf

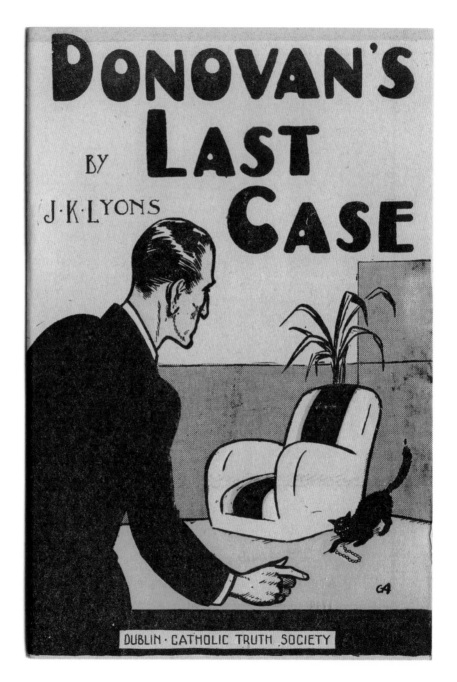

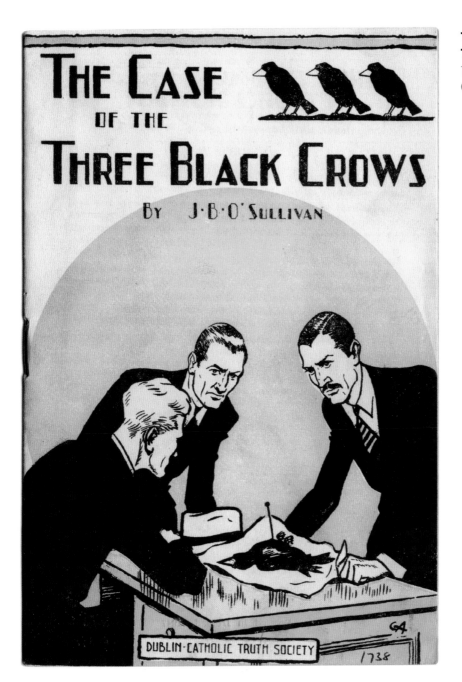

**The Case of the
Three Black Crows**
1945 *(1947 printing)*
George Altendorf

The Ghost at the Rath
1944 edition
George Altendorf

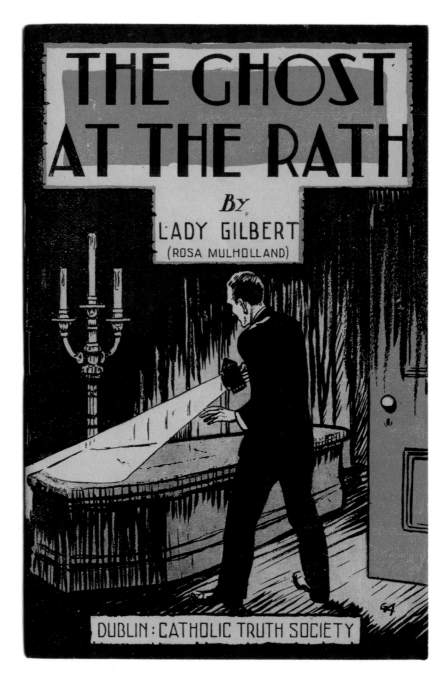

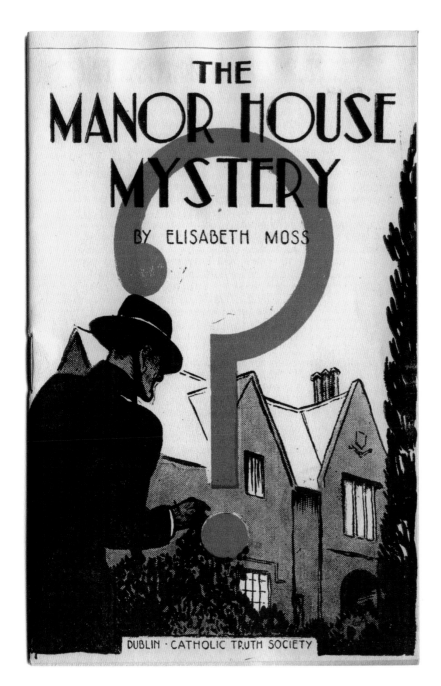

The Manor House Mystery
1948
George Altendorf

The Man in the Mirror
1948 *(1950 printing)*
George Altendorf

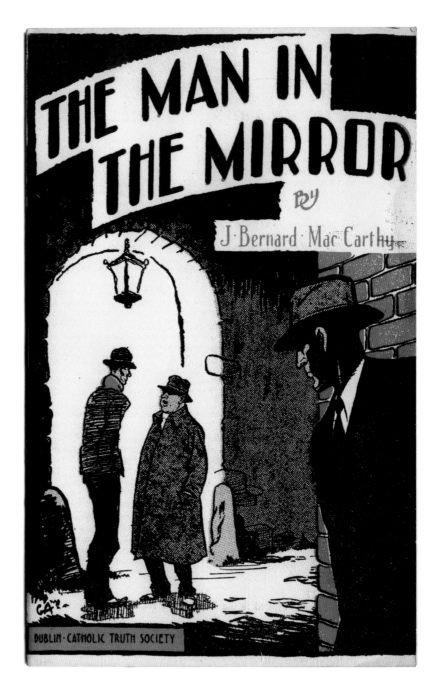

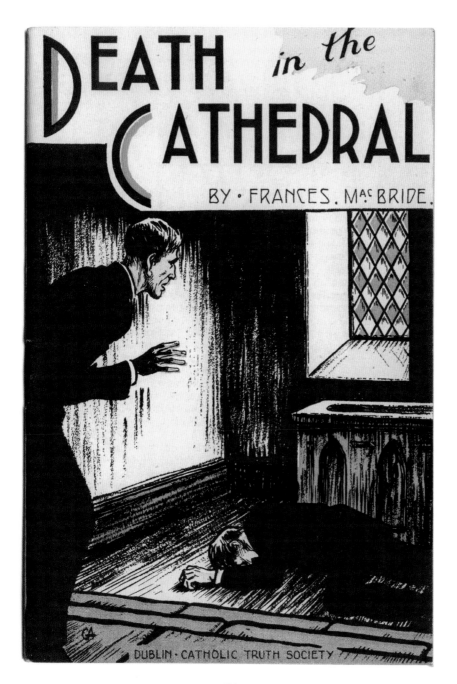

Death in the Cathedral
1946
George Altendorf

**Last Will and
Testament**
1947 *(1950 printing)*
George Altendorf

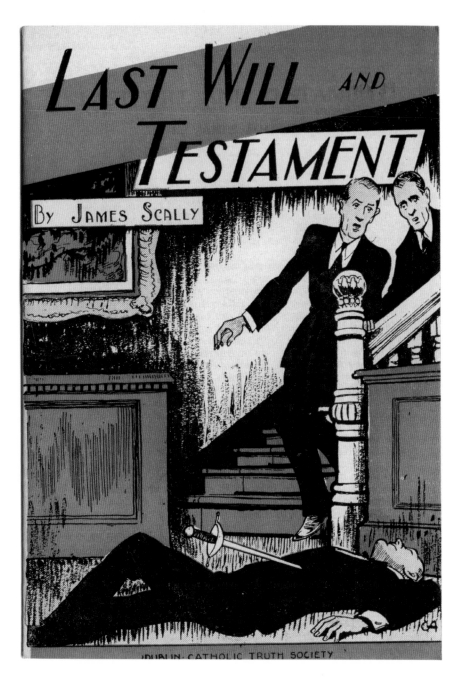

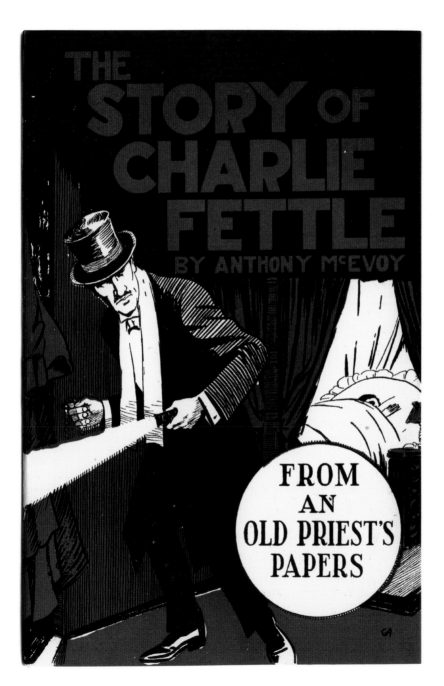

**The Story of
Charlie Fettle**
1949
George Altendorf

Partners in Fraud
1947
George Altendorf

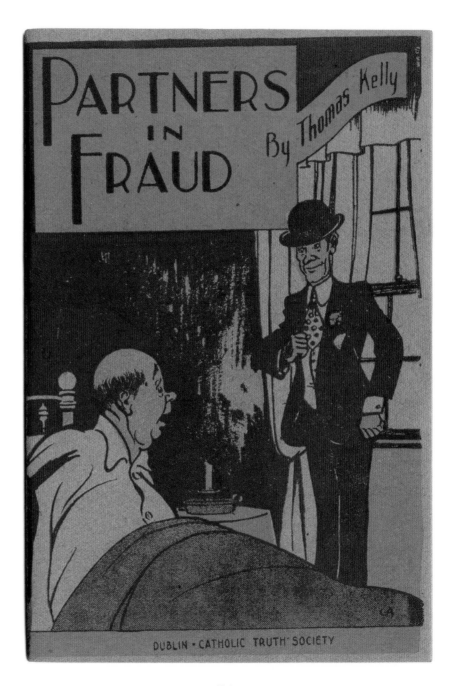

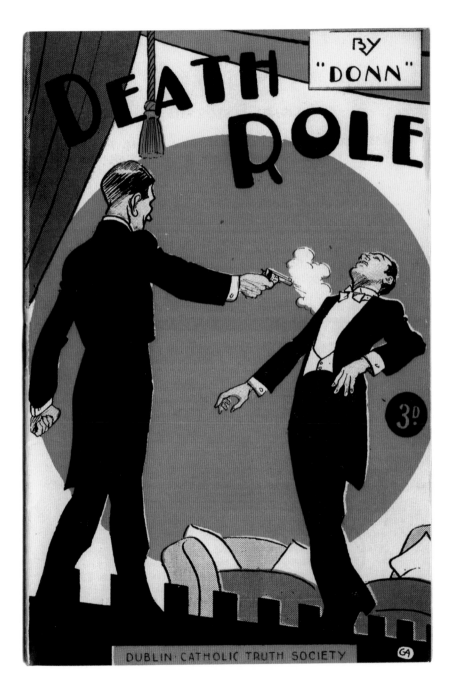

Death Role
1946 (1951 printing)
George Altendorf

The Church – The Champion of Science
1945
John Henry

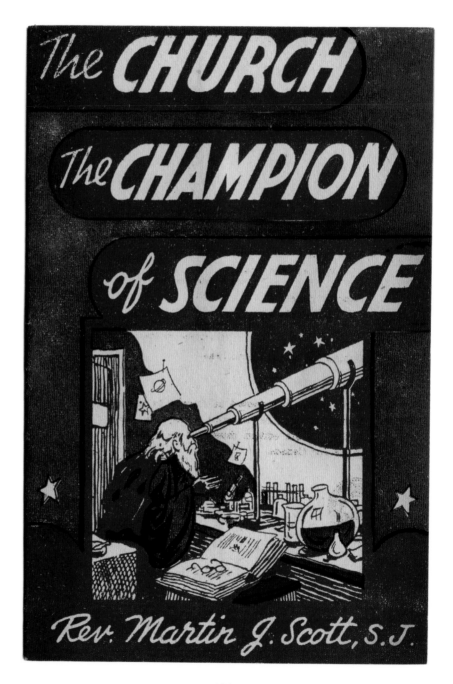

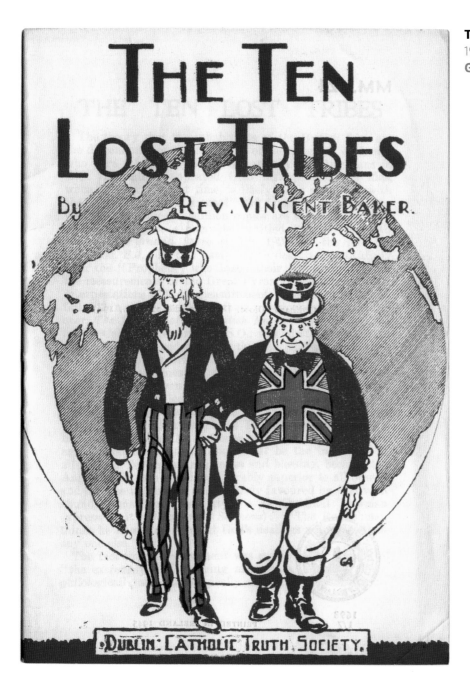

THE TEN LOST TRIBES

By REV. VINCENT BAKER.

DUBLIN: CATHOLIC TRUTH SOCIETY.

**The Jehovah
Witnesses:
A Warning to
Catholics**
1957 edition
(1961 printing)
W. Kiernan

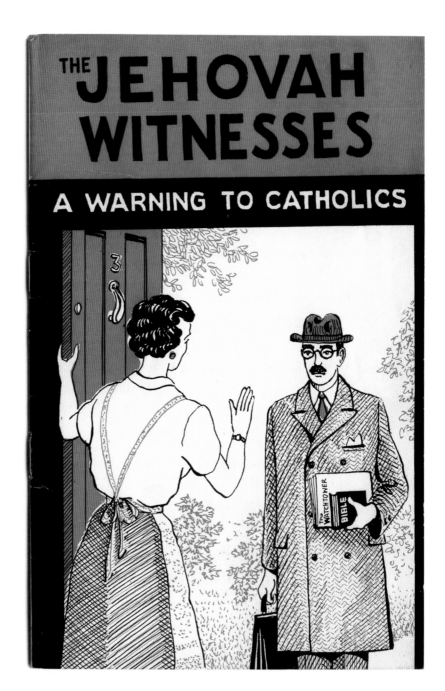

An Agnostic in an Irish Village
1963
M. Byrne

Cookery Nook
1936 *(1950 printing)*
Sean Best

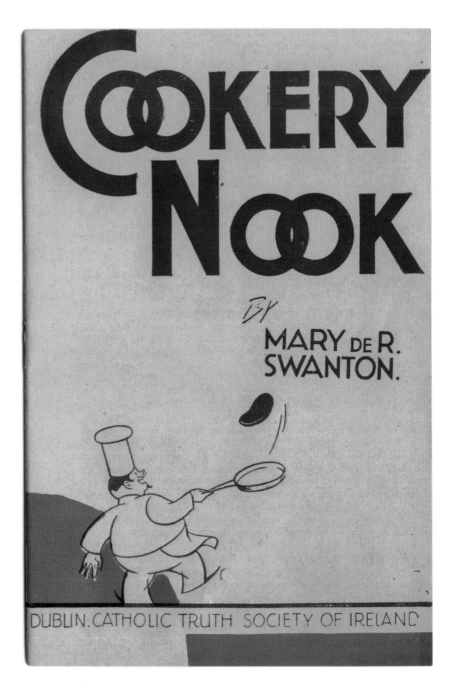

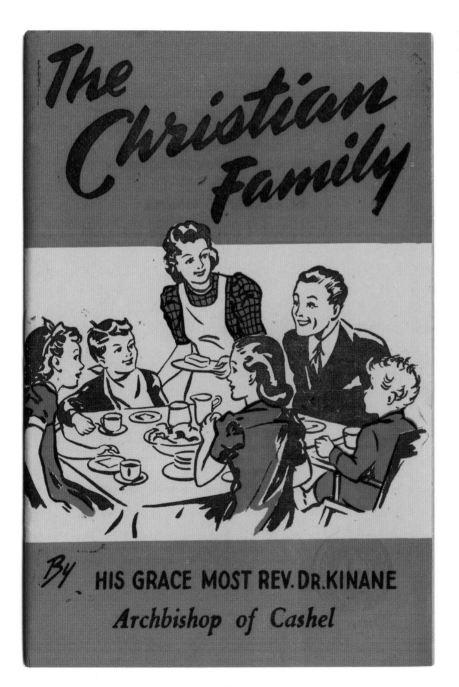

The Christian Family
1945 *(1947 printing)*
John Henry

Code For Parents
1963
M. Byrne

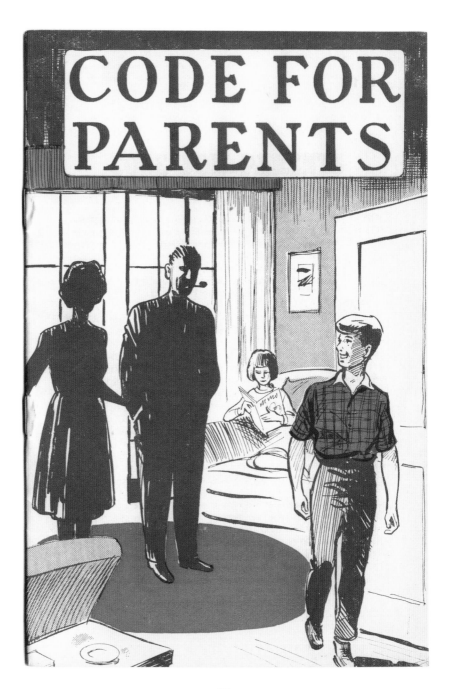

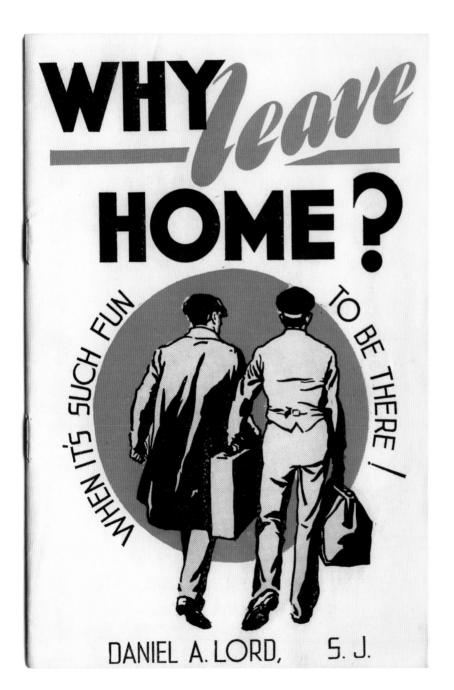

Why Leave Home?
1944 *(1960 printing)*
Sean Best

I Have Left School
1944 (1961 printing)
Sean Best

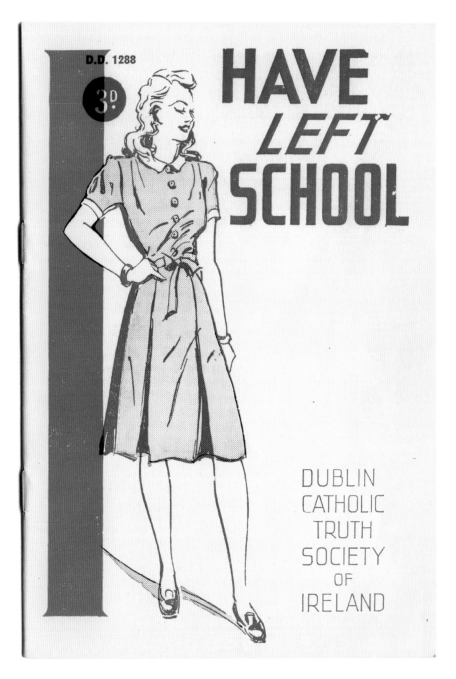

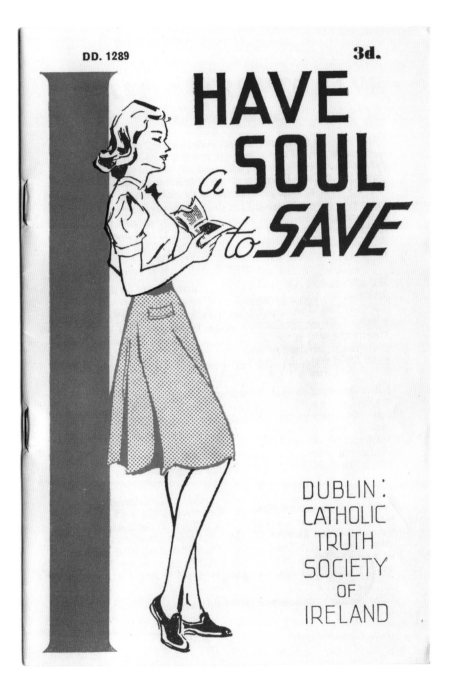

DD. 1289

3d.

I HAVE *a* SOUL *to* SAVE

DUBLIN :
CATHOLIC
TRUTH
SOCIETY
OF
IRELAND

**I Have a Soul
to Save**
1944 *(1961 printing)*
Sean Best

**The Young Lady
Says 'No'!**
1946 (*1963 printing*)
John Henry

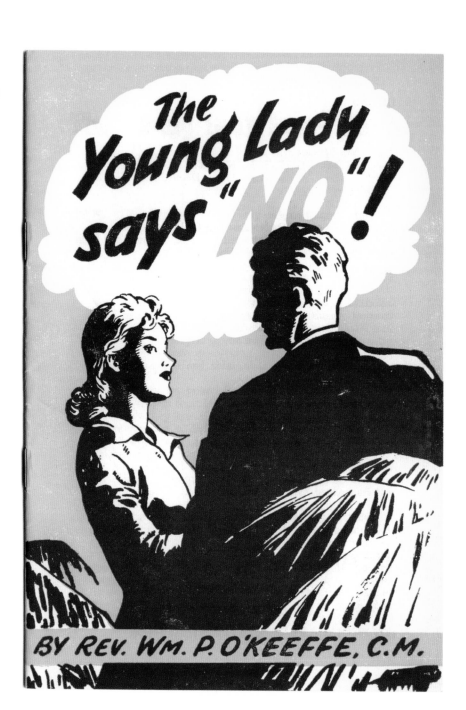

Let's See the Other Side
1943 (1958 printing)
Sean Best

What! Me a Saint?
1945
(printed after 1962)
John Henry

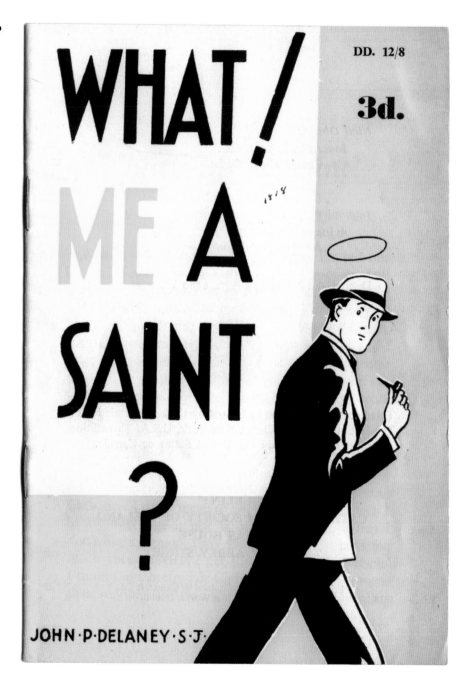

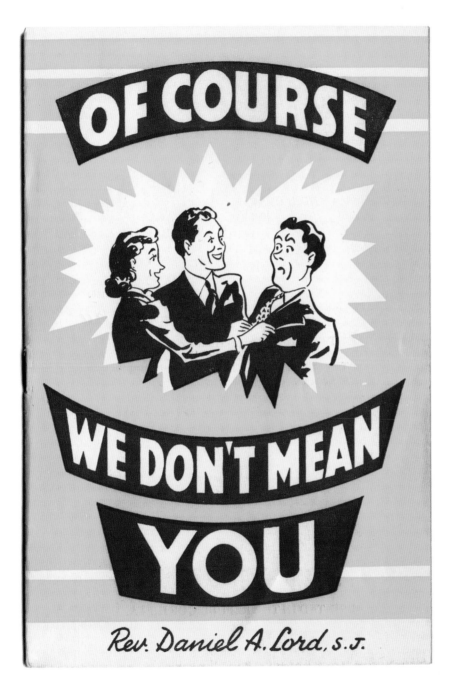

**Of Course We Don't
Mean You**
1946 *(1957 printing)*
John Henry

Seán na Sagart:
The Priest Hunter
1946 *(1949 printing)*
John Henry

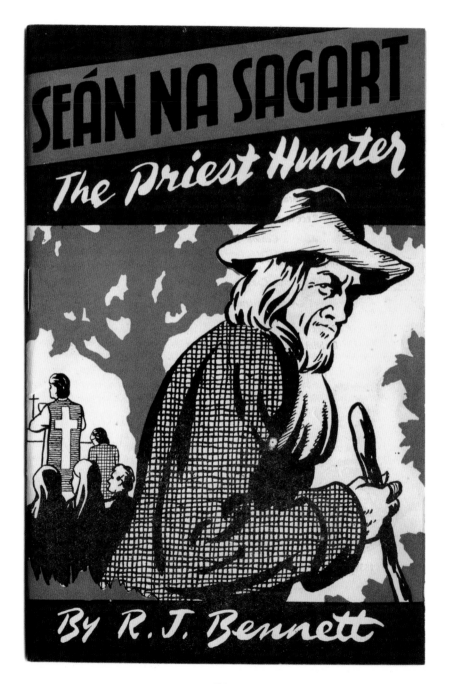

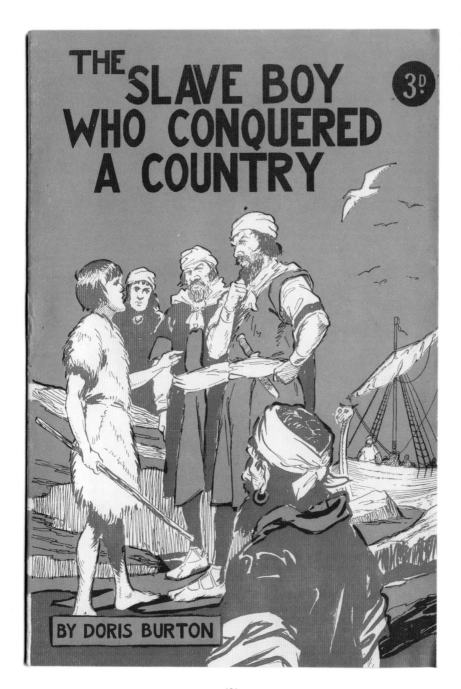

THE SLAVE BOY WHO CONQUERED A COUNTRY

3D.

BY DORIS BURTON

The Slave Boy
Who Conquered a
Country
1952 *(1958 printing)*
George Altendorf

Stories Told in a Convent
1940 (1950 printing)
George Altendorf

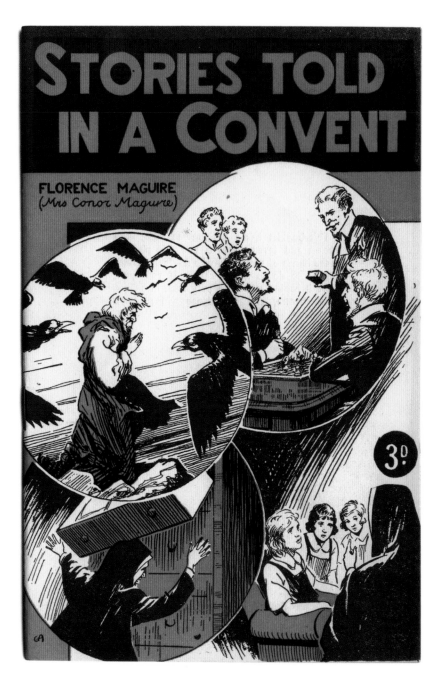

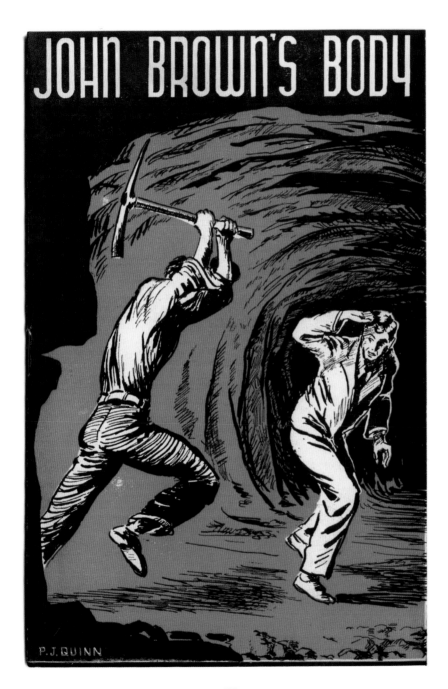

John Brown's Body
1951
P.J. Quinn

The Balloon Man
1939
Alfred Monahan

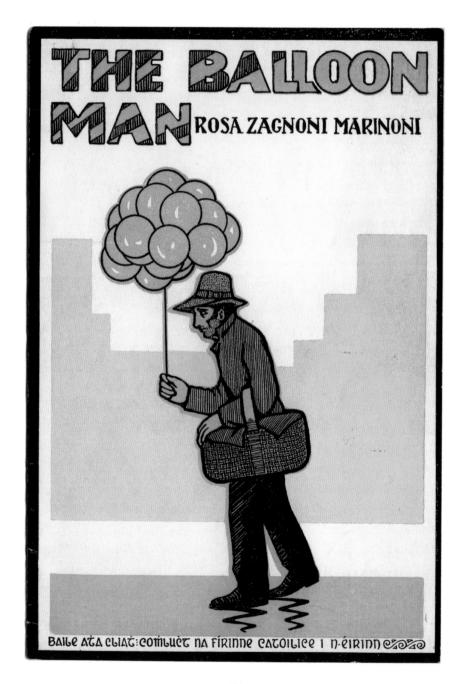

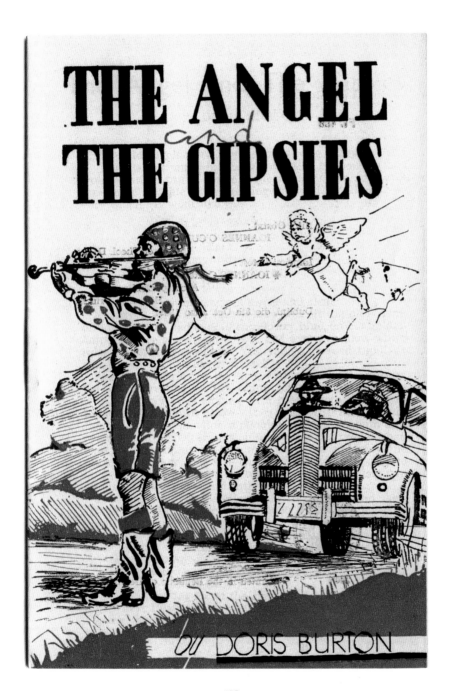

The Angel and the Gipsies
1950
J. Spellman

Artist Biographies

George Altendorf (1904–1966) was born in Dublin to a German father and Irish mother. He attended the Dublin Metropolitan School of Art and studied under Austin Molloy. Molloy was a close friend and colleague of Harry Clarke and took over his class in illustration and layout at the school after Clarke resigned in 1923. A number of talented Irish designers passed through this class, including Altendorf, Olive Cunningham, Richard King, Victor Penney and John Henry. Altendorf's brother Albert also attended the Metropolitan School and later worked as a designer in stained glass at the Harry Clarke Studios. George Altendorf became assistant art director at the Irish Press on its establishment in 1929 and went on to become art editor. He was a prolific commercial artist and cartoonist.

Alfred Monahan [Ailbhe Ó Monacháin] (1889–1967) was born in Belfast. He wrote and illustrated a number of books for Colm Ó Lochlainn's Sign of the Three Candles Press and An Gúm. For over a decade he illustrated covers and stories for *An tUltach* as well as nationalist cards and calendars for Brian O'Higgins.

George Monks was born in Dublin in 1879. He contributed illustrations and cover designs to *Our Boys* and illustrated books by Aodh De Blácam for Whelan & Son and Mellifont Press, including *Patsy the Codologist* (1922). His cover design for *The Beefy Saint* (1922) is the earliest work in this book.

Karl Uhlemann (1912–1992) was also born in Dublin to a German father and Irish mother. Uhlemann was educated at Synge Street CBS and went to work at Sign of the Three Candles Press upon leaving school. He is best known for collaborating with Ó Lochlainn on the design of the Colum Cille typeface (1936) for Stanley Morison at Monotype. Uhlemann spent a year in Germany studying under Walter Tiemann at the Akademie für Graphische Künst und Buchgewerbe, Leipzig, in the early 1930s. He was particularly adept at scraperboard illustration and produced numerous book covers for FNT, Talbot Press, Clonmore & Reynolds and the Educational Company.

Unfortunately, we have scant details of the other artists whose work is included. John Henry was a student at the Dublin Metropolitan School of

Art during the time George Altendorf was attending the school. Sean Best designed the cover of the official 1932 Eucharistic Congress programme, and W. Kiernan may be Walter J. Kiernan who took second prize in the Show Card or Catalogue Cover category in the 1929 Royal Dublin Society National Art Competition. A Martin Collins held a solo exhibition of paintings in Lad Lane Gallery in 1978 and was also working as a 'visualiser' with the Peter Owens advertising agency in the early 1980s, but it's impossible to say if either or both are the same artist who created the covers in this book.

Niall McCormack

Sources

Augusteijn, Joost, ed., *Ireland in the 1930s*, Four Courts Press, 1999

Curtis, Maurice, *A Challenge to Democracy: Militant Catholicism in Modern Ireland*, The History Press Ireland, 2010

King, Linda and Elaine Sisson, eds, *Ireland, Design and Visual Culture: Negotiating Modernity, 1922–1992*, Cork University Press, 2011

McGuinne, Dermot, *Irish Type Design: A History of Printing Types in the Irish Character*, Irish Academic Press, 1992

Oram, Hugh, *The Advertising Book: The History of Advertising in Ireland*, MO Books, 1986

Snoddy, Theo, *Dictionary of Irish Artists: 20th Century*, 2nd ed., Merlin Publishing, 2002

Turpin, John, *A School of Art in Dublin Since the Eighteenth Century: A History of the National College of Art and Design*, Gill & Macmillan, 1995

Registers of the Dublin Metropolitan School of Art, Nival, NCAD

The Talbot Press Archive, National Archive of Ireland, NAI/1048/1/132–135

The Irish Times, 9 April 1953

Websites

Irish Comics Wiki: irishcomics.wikia.com

Vintage Irish Book Covers: hitone.wordpress.com